Alberta

A History in Photographs

Sept 2000

We hope you enjoy,
your new prospects
out west!

Love from
Mary, Richard
+ Pamela

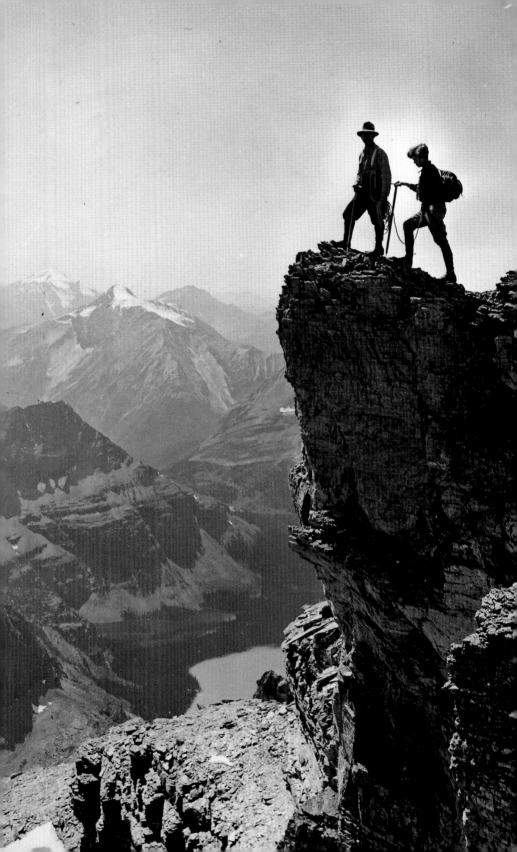

Alberta

A History in Photographs

Faye Reineberg Holt

Altitude Publishing
Canadian Rockies/Vancouver

Cover: *Adventurer Koote-nay Brown was considered a lawless renegade by some and a hero by others. Eventually leaving behind a life as a whisky trader and wolfer, he became one of Alberta's early conservationists, and was instrumental in the establishment of a forest reserve at Waterton.*

Frontispiece: *The 1931 movie,* She Climbs to Conquer, *was filmed on Mount Victoria at Lake Louise. Actress and mountain climber Georgina Engelhard hailed from New York. With her is CPR Rocky Mountain guide E. Feuz, who appeared as a double in climbing scenes for the movie.*

Opposite: *In 1922 the show jumping of Dorothy Wood on her mount, Sir Aran, thrilled Edmonton Exhibition crowds. Special guest of the exhibition was Governor General Lord Byng.*

Back Cover: *Stoney Natives racing horses in the foothills near Morley, 1907.*

Publication Information

Canadian Cataloguing in Publication Data
Reineberg Holt, Faye.
 Alberta
ISBN 1-55153-901-2
1. Alberta--History--Pictorial works. I. Title.
FC3662.R44 1996 971.23'02'0222 C96-910137-6
F1076.8R44 1996

Design: Stephen Hutchings
Electronic page layout: Catherine Burgess, Sandra Davis
FPO Scans: Tracy Whillans
Editor: Joel Riemer
Financial management: Laurie Smith

Made in Western Canada
Printed and bound in Canada
by Friesen Printers, Altona, Manitoba.

Altitude GreenTree Program
Altitude Publishing will plant in Canada twice as many trees as were used in the manufacturing of this book.

9 8 7 6 5 4 3

Altitude Publishing Canada Ltd.
1500 Railway Ave
Canmore Alberta T1W 1P6

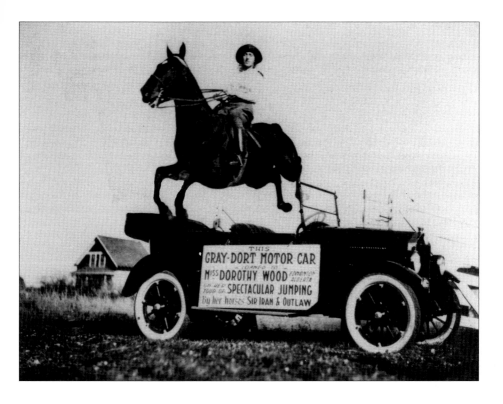

Contents

Furs and Bison

Alberta's human history dawned with a great journey over the Bering Strait into Canada's North. The province's first people, the Besant, left traces of their civilization near the mountain town of Canmore. Throughout the province, they left descendants, the First Nations of Alberta. While pushing south, the Besant created an ancient route known as the Wolf Track Trail. Centuries later much of it would be paved as the major north-south traffic corridor linking the province.

Historically, the First Nations were also linked by complex ties of blood and diplomacy. The Chipewyan were the people of the northeast. The northwest was home to the Beaver and Slavey Nations. The Stoney, near present-day Nordegg and Morley, had ties with the American Sioux.

The Plains and Woodland Cree claimed a vast territory extending from northern Alberta, south to the Red Deer and Battle Rivers. This territory bordered lands belonging to their enemy, the Black-foot, and when hunting parties met, tensions often escalated into legendary battles.

The south's Blackfoot Confederacy united the Blackfoot proper, whose name denoted moccasins blackened by prairie fires, with the Blood or *Kainai,* meaning "many chiefs", and the Peigan or *Piikani.*

Also joining the Confederacy, the *Tsuu T'ina* or Sarcee from near Calgary were actually descended from the north's Beaver people. A chief had killed a dog and was shot in retribution. The ensuing hostilities claimed 80 lives, after which 60 exiles fled south, adopting the plains lifestyle.

There the buffalo were the essentially sole source of food, tools, clothing, bedding, and teepees.

Originally hunting on foot, native people drove the buffalo into pounds to be shot with bow and arrow, or drove them over cliffs known as jumps. Used at least 5600 years ago, Head Smashed In Buffalo Jump near Fort Macleod may have an 11,000 year history. With stampeding bison reaching 64 kilometres per hour [40 miles per hour], danger was ever-present. Glory and sport became associated with the hunt only after the advent of horses and guns.

That glory proved to be short-lived. Soon, European-style trade and trophy hunting meant the disappearance of food sources.

Horses and guns also escalated conflict. Stealing horses from the enemy was considered courageous, although traditionally the greatest honor was bestowed for simply physically contacting or unseating an enemy. With the fur trade's guns and whisky, violence and deaths skyrocketed.

The appearance of new diseases, vices, and values also irrevocably changed the First Nations.

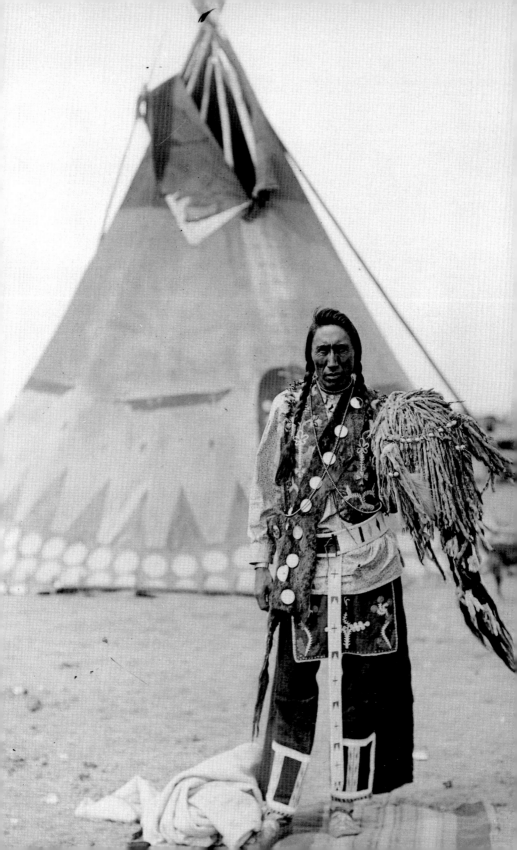

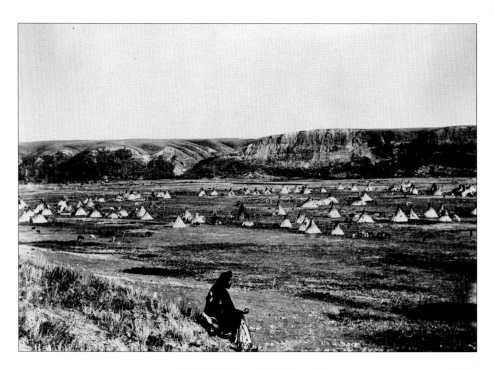

Top: *In 1754, Hudson's Bay Company labourer Anthony Henday became the first European to see Alberta. Travelling with Cree guides, he followed the North Saskatchewan and Battle Rivers. Wintering at a Blackfoot camp south of the Red Deer River, he reported that the people were well-dressed, and society was orderly. Two hundred teepees lined a broad street stretching 1.57 kilometres [one mile], while this sun dance camp from the late 1800s has only 90 teepees. The next spring, Henday became the first non-native to view Alberta's Rocky Mountains.*

Bottom: *Before 1730, dogs pulled the travois to move camp, so teepees were small, typically consisting of 14 to 21 buffalo robes. With the advent of horses, the wealthy could own teepees made of as many as 30 robes and accommodating up to 100 people during a meeting. First acquiring horses during a battle with the American Shoshoni, the Peigan referred to them as "elk-dogs" or "big dogs." Immediately valued for moving and hunting, horses also conferred status. Most families had 10, but one wealthy Peigan acquired 300.*

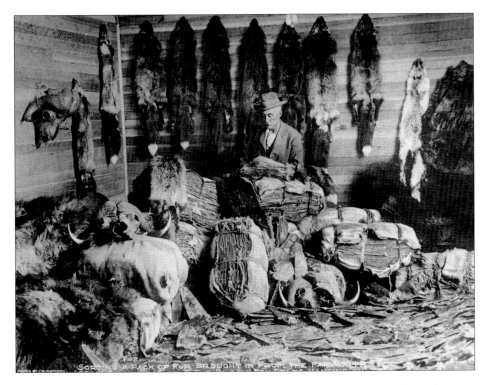

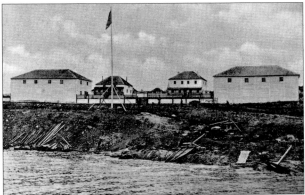

Bottom: *Built by the North West Company in 1788, Fort Chipewyan on Athabasca Lake, 805 kilometres [500 miles] north of Edmonton, was Alberta's first important fur trading post. Ten years earlier, Chipewyan trader Peter Pond had been the first non-native to erect a building in Alberta. While in charge of the fort, he explored the Peace River and mapped Alberta's north. In 1789, second-in-command Alexander Mackenzie explored the river named in his honor, the longest in Canada. The next year, he discovered an inland route to the Pacific.*

Top: *In 1779 Peter Pond came out of the North with 80,000 beaver skins for men's top hats. Eventually implicated in the murders of two competing traders, Pond left Canada. With changing fashions, the market for beaver declined, but other furs became popular. This trader from the early 1900s is surrounded by furs worth $35,000. Traders could sell black fox pelts for $500. A sleigh robe made from a wolf pelt would cost a consumer $20.*

By 1795, the first Fort Edmonton was built by the Hudson's Bay Company near today's Fort Saskatchewan. Rivals were always anxious to situate forts farther up river than the competition. One company would build, and then the other would erect a fort nearby, sometimes in the same stockade. Although companies were competitors, employees were neighbours and often friends. Many forts bore two or more names, for they were built, abandoned when local fur-bearing animal populations were depleted, then rebuilt when those populations rebounded, typically a cycle of eight years duration.

Fort Edmonton's twin was the North West Company's Fort Augustus. The first four sites were abandoned, but finally, in 1812, the last fort was erected where the provincial legislature stands today. The palisade was 60 by 90 metres and 6 metres high [200 by 300 feet and 20 feet high].

In 1825, chief factor John Rowand built the fort's Big House, considered the most impressive structure west of Fort Garry. Nicknamed Rowand's Folly, its extravagances included real glass windows in the three-storey building where he entertained lavishly.

A frequent visitor was the last and perhaps greatest Alberta explorer. Working as a trader for 28 years, London-born David Thompson travelled 80,465 kilometres [50,000 miles], mostly near the North and South Saskatchewan Rivers. For his surveying and map making, he utilized unsophisticated instruments. Nevertheless, he was able to create maps with accurate latitudes and longitudes. In addition, he recorded the flora and fauna which he encountered. His Metis wife and children often travelled with him and spent time at Edmonton and Action House [HBC 1799], also called Rocky Mountain House [NWC].

Edmonton hosted Alberta's first two missionary visitors. Arriving at the fort in 1840, the Methodist R. T. Rundle became the first missionary to actually work and make his home in Alberta. Two years later, he was joined by A. Thibault, a Roman Catholic priest; and in 1852 the most famous Alberta missionary, twenty-year-old Father Lacombe, arrived. He helped found the first school and was instrumental in building the first flour mill.

Life near Edmonton was reasonably orderly and law-abiding, except when the Cree and Blackfoot clashed. Although introduced by traders, brandy was originally reserved for ceremonial purposes. Then independent traders, and eventually the HBC, found that plying native traders with alcohol meant lower costs. Liquor became a bartering tool, and then a trade item. However, by 1870, with public pressure and reduced competition after the 1821 amalgamation of the HBC and NWC, Edmonton, like other respectable HBC posts, no longer traded in whisky.

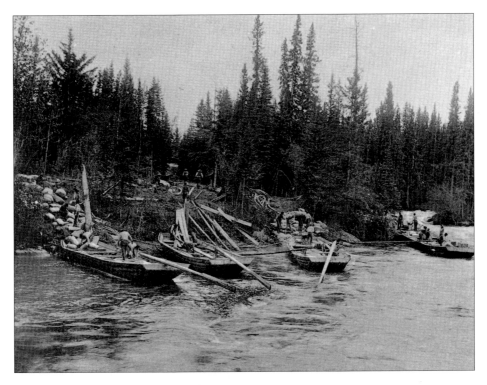

Top: *Early in the fur trade, freight canoes were used, but then the HBC developed a safer and larger boat. Called the York boat, it had a fairly flat bottom, twice the capacity of a canoe, and was equipped with a sail. It required the same crew as a ca-* *noe, but could hold 80–90 fur bales. Eventually, at Edmonton, building York boats became one man's full-time job.*

Bottom: *Trade currency was the beaver pelt, known as the "made-beaver." Other furs* *such as muskrat, bear, or marten were given made-beaver equivalents for purchasing blankets, kettles, tobacco, sugar, gun powder, or coloured beads.*

To prepare furs for transportation, a fur press compacted the 36 kilogram [80 pound] fur bales to be sent east. About 100 beaver, 250 marten, and 16 lynx pelts comprised one bale. Claws and scent glands were removed. The larger fur pelts were placed closer to the outside, and the bale was covered in canvas.

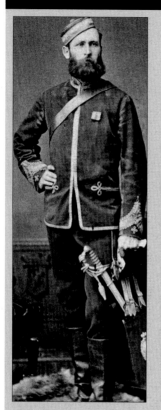

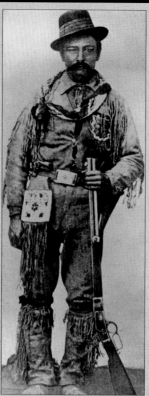

WELL-ARMED American whisky forts on Canadian soil became a concern, escalating to public outrage, with news of the Cypress Hills Massacre of Canadian native people. Tentative plans already existed to send a police force into the prairies to negotiate treaties. Following the massacre, Prime Minister Macdonald, fearing a native uprising, sent three divisions of the newly-formed North West Mounted Police.

The march west was a horrendous ordeal. Horses perished. Men became exhausted, drank liquid mud for tea, and were close to starvation before finding buffalo on the prairies.

On September 8, 1874, the force camped near present-day Medicine Hat. With not a tree for 60 or 70 miles and supplies exhausted, they turned south to the Sweet Grass Hills on the Montana/Alberta border. After four days, they moved camp to the Belly River, expecting to find Fort Whoop-up and hundreds of outlaws. Instead, they encountered three roofless and abandoned log buildings, but these were not the sought-after Whoop-Up.

To replenish supplies and telegraph for orders, Commissioner French, Major James Macleod (left), and a small troop travelled to Fort Benton, Montana. This group then returned to Alberta, where Major Macleod and a large contingent remained. French and his troop backtracked to establish a headquarters in Manitoba.

Before leaving Montana, French and Macleod had hired Jerry Potts (right) as a guide and interpreter. Working in Fort Benton for merchant I. G. Baker, Potts knew the prairie geography and people well. His murdered father had been a Scot fur trader for an American company. His mother was from the Alberta Blood nation.

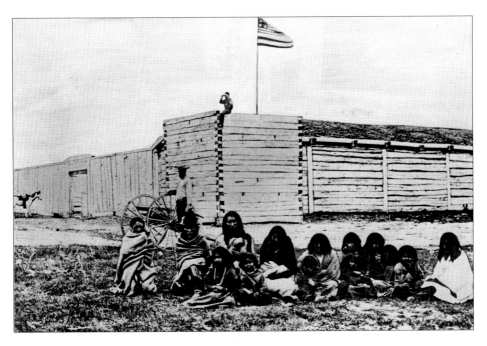

Top: *Fort Hamilton, more commonly known as Fort Whoop-Up, had been built in 1869 by American traders John Healy and Alfred Hamilton, both with ties to Baker. This first and most notorious of the whisky forts was on the site of present-day Lethbridge. The Stars and Stripes flew over the lawless fort where whisky and repeating rifles were traded for buffalo robes. One robe purchased 2 1/2 litres [1/2 gallon] of firewater—a concoction commonly including whisky and most, or all, of the following: sugar, molasses, chewing tobacco, red pepper, ginger, soap, red ink, strychnine, and copper sulphate.*

Bottom: *Cannon ready, the NWMP arrived at Whoop-Up in October, 1874. Over 50 people had died there during whisky trade incidents, but forewarned, the principal traders had disappeared. Finding no alcohol and needing a barracks, Macleod offered to buy the outpost.*

When its caretaker set too high a price, Potts guided the force to a site on the Oldman River where timber was available; and the construction of Fort Macleod commenced. Before it was completed, whisky trader D. W. Davis appeared, to render assistance as a building contractor for I. G. Baker.

Top: *Before the NWMP patrols commenced, life near the whisky forts and the hunting grounds of wolfers and hide hunters was unpredictable, confrontational, and brutal. During the initial year of patrols, Potts guided the force to Pine Coulee, where the first whisky traders were arrested. This patrol camped near Standoff, one of about 40 posts trading in whisky and guns. Other well-known whisky forts were Spitzee [Highwood River], Robbers Roost [Monarch], Slide Out, Cypress Hills, and Tail Creek.*

In 1875, the federal government passed a prohibition law for the North West Territories, including Alberta. Only by special permit was it possible to import liquor for personal use. The NWMP seized and destroyed contraband, but they also had the power to charge suspects despite little evidence, and to search without a warrant. In 1877, when the Mounties arrested three whisky smugglers, the Fort Benton newspaper reported, "they fetch their man every time." That became the motto, "They always get their man."

Within a very few years, the NWMP had built additional forts. In 1875, D. W. Davis was contracted to build Fort Calgary, where he established an I. G. Baker grocery and hardware store. Law and order prevailed, and former outlaws turned respectable. In 1887, Davis became Alberta's first Member of Parliament in the Territorial government.

Opposite bottom: *The First Nations trusted the NWMP. In 1876, most Wood and Plains Cree signed Treaty 6. A year later, the Blackfoot Confederacy signed Treaty 7 at Blackfoot Crossing.*

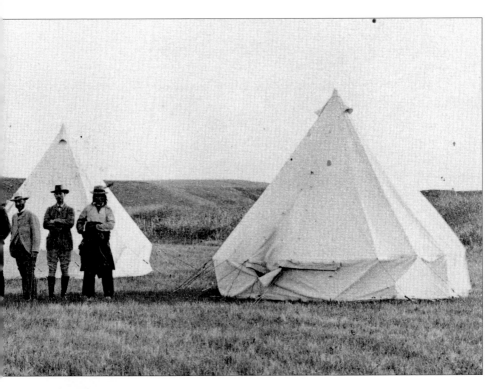

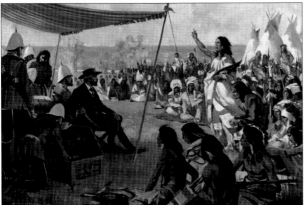

For 129,490 square kilometres [50,000 square miles], the government paid $12 to each band member and $15–$25 to each chief. A $5 annual annuity and promises of ammunition, cattle, tools, seed, and food in time of famine completed the agreement.

Difficulties arose, however. The Mounties assumed Chief Crowfoot was leader of all the Confederacy. Sarcee and Blackfoot were assigned the same reserve, and the miscalculation created tensions. But the biggest problem was food.

The buffalo were virtually extinct. Assigned to reserves, native people found hunting territory was diminished. An 1870 smallpox epidemic had claimed thousands and debilitated many others. Food deliveries were erratic, and between 1879 and 1881, another 1000 of 6000 Blackfoot starved. Only decades later would Alberta's indigenous people experience revival.

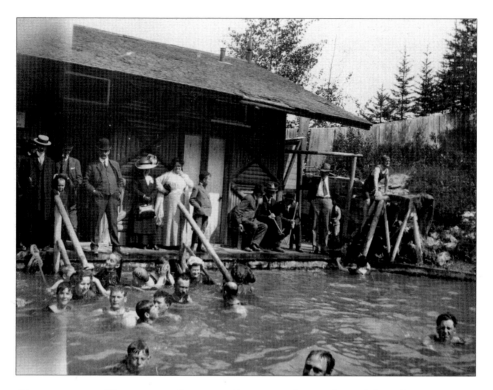

Opposite top: *Kootenay Brown (seated right) was both whisky trader and wolfer. Instead of paying native hunters, a wolfer would poison a buffalo carcass with strychnine, and might net 20 wolf pelts. When Mountie law prevailed, Brown became a respectable hunting and fishing guide. Instrumental in establishing Waterton Park, he served as its first superintendent.*

Opposite bottom: *Almost entirely populated by young males, mining and railway towns were rowdy, but there were few serious crimes. The most common were gambling, liquor infractions, theft, rustling, and non-payment of wages. In winter, especially in the mountains, the NWMP often used dog teams. A detachment of Calgary's E Division, these Mounties were stationed at Siding 29 [Banff].*

Top: *The earliest visitors to the Cave and Basin Hot Springs were indigenous people. In 1876 the first white men entered by a hole in the cave's roof. Rediscovering this natural phenomenon in the 1880s, CPR surveyors Tom and William McCardle and Frank McCabe recognized the tourist potential and built a shack to accommodate guests. With Siding 29 a regular stop in CP rail service, an enterprising couple, the O'Keefes, decided to build a small hotel, and another portable hotel arrived from Montreal. Banff tourism had arrived.*

The southern Rockies attracted their share of fortune seekers as well. Criss-crossing the territory in search of gold, prospectors were especially attracted to the North Saskatchewan River and the mountains. Fort Whoop-Up's John Healy, supposedly a prospector but in reality more a promoter of questionable honesty, co-founded Silver City at Castle Mountain. News of a copper discovery changed to rumours of a gold and silver strike, and by 1883, 351 had flocked to the boom town. Shares were sold in the Queen of the Hills Mine, and at its height, the town was home to 3000. When the mine proved unproductive, Silver City became a ghost town.

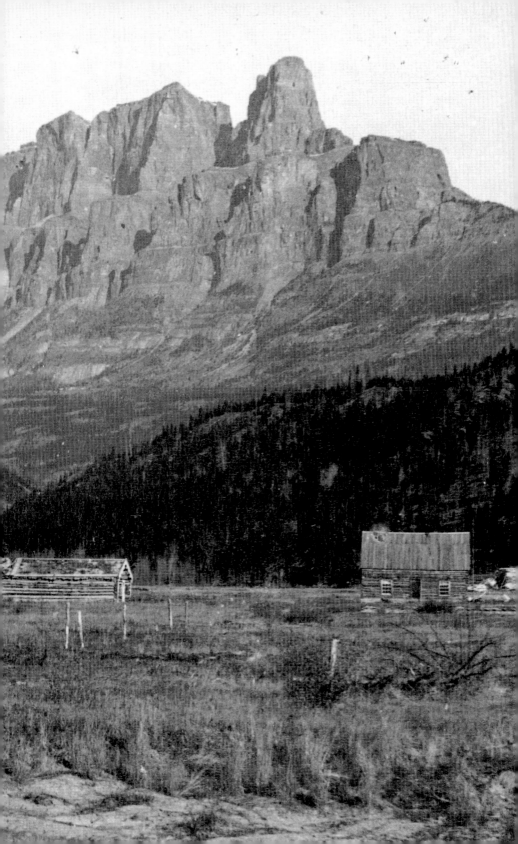

Ranches & Rails

With treaties and an end to the whisky traders' reign of violence, legitimate merchants, farmers, and ranchers began eyeing Alberta. To transport settlers, fulfill treaty promises, supply the NWMP, and affirm Canadian territorial integrity, a transcontinental railway became a necessity. Construction through the prairies would require provisions for thousands of labourers. That bullish market gave birth to large scale ranching in southern Alberta.

Most early ranches were stocked from American herds. During the 1870s, the McDougall family expanded its Morleyville herd with cattle driven from Montana. Ranching near Fort Macleod, Joseph McFarland, who supplied the NWMP, grazed a small herd also brought from Montana.

Having their own ranches appealed to drovers such as Tom Lynch, who chose the Highwood River area. The OH Ranch, the site of today's High River, was started by O. H. Smith, an American trader and freighter I. G. Baker and other Montanans owned the Circle Ranch near Medicine Hat. One-time prospector, scout, and freighter Sam Livingston farmed near Calgary. After their three year term of duty, former Mounties also became ranchers. Retired from the army, Major-General Thomas Strange leased 90,000 acres of land along the Bow River and established one of the first of many colonization schemes. His Military Colonization Ranch faced financial and management difficulties and was eventually sold.

Government supply farms were also established, one at Fish Creek and another at Pincher Creek. Indigenous people were often employed since officials hoped they would become farmers.

Word had spread about the strong market and high prices for beef in southern Alberta. Already, farming was successful near Edmonton and along the North Saskatchewan River. By the 1900s, agriculture had "taken root" throughout the province.

Legislation allowing crown land to be leased had been the incentive for investment in huge ranches. In the 1880s, British investors backed ranches such as the Oxley and the Walrond, but few ever saw the spreads. However, ranch life was the dream of many. When the Marquis de Lorne toured in 1881, he stated, "If I were not Governor General of Canada, I would be a cattle rancher in Alberta."

Often, purchases on a massive scale meant unhappy creditors at the heels of ranch managers, while management was sometimes so distant it neither understood the problems nor worried about a tardy response to financial crisis. Nevertheless, sprawling ranches created some of Alberta's best known millionaires.

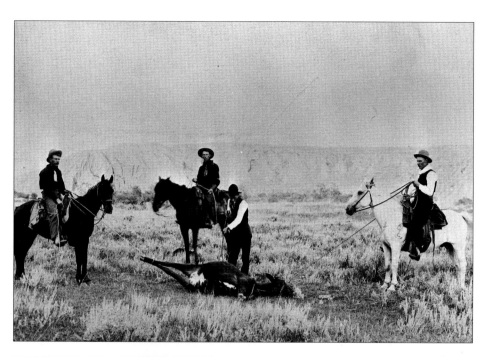

Bottom: *These cowboys worked for the Bar U, one of the earliest and best known ranches. Established in 1882 by Fred Stimson, the North-West Cattle Company [Bar U] leased range along the Highwood River. For financing, Stimson turned to a wealthy eastern steamship owner, Sir Hugh Allen. Three thousand cattle driven from Idaho stocked the first herd. One cowboy riding the herd was John Ware, Alberta's first black rancher. Although Ware was never thrown from a horse, about 20 years later, his mount stumbled, rolled on him, and took his life.*

Top: *Cattle freely grazing on crown lands and cattle rustling meant that branding was important to establish ownership. Despite being free-spirited, cowboys worked together, whether branding cattle or herding them in huge round-ups each spring and fall. In 1885 the round-up required 100 men and brought in 60,000 cattle. For efficiency, round-ups were soon staged by district.*

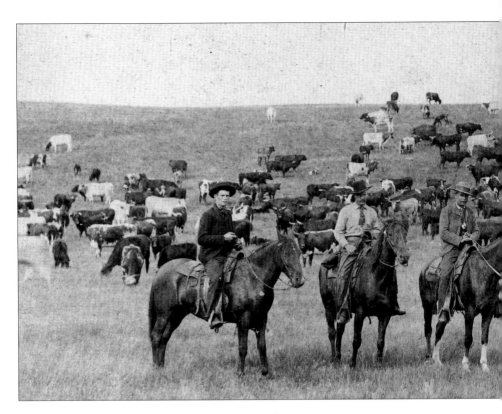

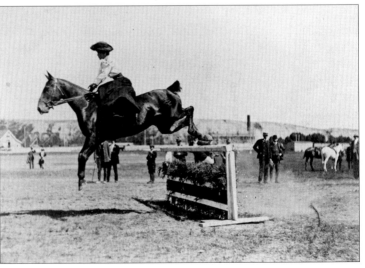

Right: *In many pioneer families, riding was considered an essential skill and a sport for both sexes. Performing at a Calgary horse show, Minnie Gardner demonstrates her talent. Her brother Clem was named All Around Canadian Cowboy in the first Calgary Stampede. He also competed in the first chuckwagon races and won them in 1931. The Gardner family arrived in Alberta in 1886 when Clem was an infant. The journey from Manitoba was by covered wagon.*

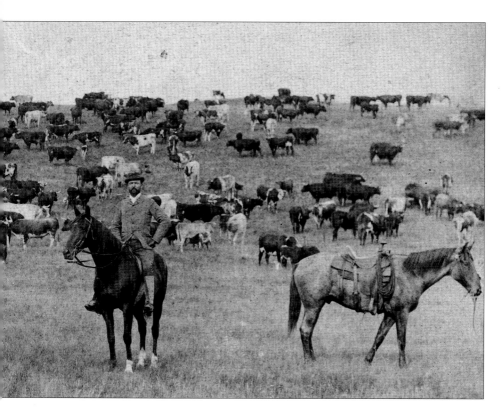

Top: *In 1883, learning of the phenomenal market for horses in Alberta, Kamloops rancher William Roper Hull (on the right) drove 1400 horses from British Columbia to Fort Macleod. Arriving with 1200 head after six months on the trail, he sold most to the NWMP and Bar U Ranch.*

A year later, the English immigrant extended his butcher shop holdings to Calgary, and in 1886 he drove a huge cattle herd into the province. Hull marketed some, and the rest stocked the "25", his new *ranch near Nanton. Eventually, he sold the 25 to a Scottish syndicate, acquired other grazing leases, and amassed a ranching empire.*

He purchased the 16,188 hectare [4000 acre] Fish Creek Government Supply Farm [Bow Valley Ranch] once owned by John Glenn, who was the first to establish a permanent farm near Calgary. In 1903, Hull expanded his holdings to include the New Oxley Ranch. In 1906, he acquired the leases of the Walrond, which he eventually sold to Pat Burns.

A millionaire, Hull owned shares in many companies, including the Alberta Grain Exchange and the Calgary Brewing and Malting Company, but he also funded Calgary's earliest large scale theatre, the Hull Opera House. Although a rancher, he usually dressed in the tweed jacket and derby-style hat of an English businessman. His mansion had a pool room, where Hull, wearing a red dinner jacket, often entertained southern Alberta elite ranchers, politicians, and investors.

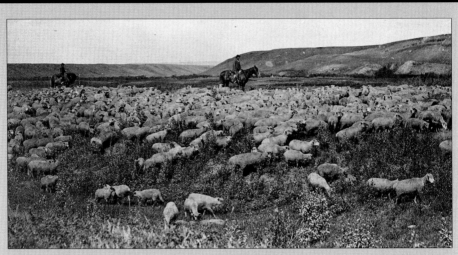

MANY RANCHERS grazed their herds on empty crown lands. By 1881 federal legislation was passed allowing ranchers to rent up to 40,470 hectares [100,000 acres] of these lands for one cent per acre per year. Quebec Senator Cochrane, the driving force behind the legislation, had already established his Alberta ranch and immediately leased land along the Bow River.

Cochrane sent 60 purebred Hereford, Shorthorn, and Angus cattle by rail and boat to be trail-driven the last leg of the journey to his ranch. In 1881 an additional 6700 cattle were purchased in Montana.

Thirteen of I. G. Baker's cowboys herded them north but, driven too hard and assailed by bad weather after their arrival, many cattle died. However, in 1882, under the management of former NWMP superintendent James Walker, the Cochrane Ranch was supplying beef to natives and the NWMP.

That year 5000 more Montana cattle arrived. The winter was severe, claiming about 3000. Persevering, the Senator and his son decided to diversify. The cattle business, still called the Cochrane Ranch, was moved south to a lease on the Waterton and Belly Rivers. The Bow River holding, renamed the British Amer-

ican Ranch, was used for grazing sheep. In 1887, a snow storm and fire claimed 1000, but the sheep remained economically viable.

At one time, the family controlled or owned 135,372 hectares [334,500 acres] in southern Alberta. By the 1890s, settlers wanted land, and the government pressured Cochrane into relinquishing leases. He purchased three quarter sections, and his son homesteaded on another quarter, but both the Cochrane Ranch and the British American Ranch began to decline. When the Senator died, his Waterton holdings were sold to the Mormon Church.

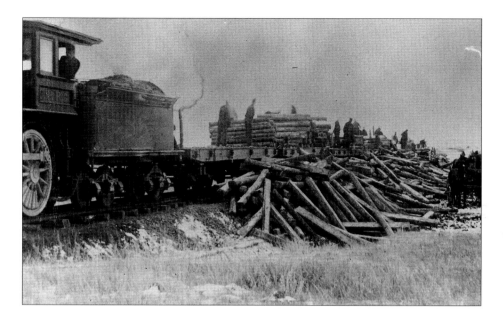

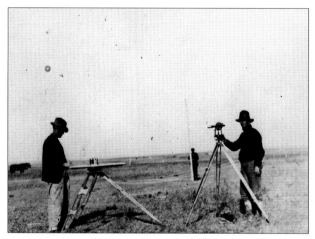

Top: *Growing knowledge about and interest in Western land, development, and resources caused business tycoons and government to join forces in building a cross-Canada rail link. Construction of the Canadian Pacific Railway changed the face of Alberta. In 1883, from mid-June to mid-August, 290 kilometres [180 miles] of track between Medicine Hat and Calgary were laid. Ties transported to the end of the track were then hauled by horse and wagon to labourers. Near Brooks, track-laying set a world record with 14.5 kilometres [nine miles] completed in one day.*

Bottom: *Surveying the open spaces became essential to orderly development. The Boundary Commission, Alberta's first survey authority, established the southern border. Beginning in 1871, the Geographical Survey of Canada mapped lands into sections and townships, recorded scientific information, and thus affected settlement policy. For the railways, the surveys determined the location of track and of communities along the line. Eventually, oil and gas industries, road building, and irrigation also depended on accurate surveys.*

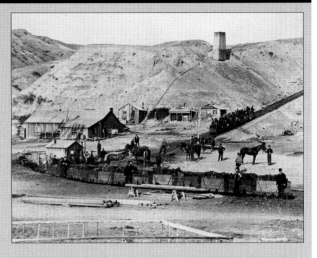

COMING TO Coal Banks [Lethbridge] as assistant Indian commissioner, Elliot Galt soon recognized that local coal deposits could mean wealth. He convinced his father Sir Alexander Galt, Canadian High Commissioner in London and a Father of Confederation, that business would be brisk in the West. They and other investors, including British book mogul W. H. Smith and William Lethbridge, established the North Western Coal and Navigation Company in Alberta. Eligible for inexpensive leases and free-hold purchases of coal lands, the company began operation by 1883.

The mine site was 109 miles from the CPR main line, so coal delivery was problematic. First, Elliot Galt had the 59 metre [173 foot] *Baroness* stern wheeler built. By 1883 it had transported the first small load of coal to Medicine Hat. The next year, he added the steamer *Alberta* and a tugboat, but low water levels remained an obstacle.

The next step was to build a narrow gauge railway. Guaranteeing fuel to settlers and western railways in exchange for a subsidy of 965 hectares per kilometre [3840 acres per mile], Galt built his line to the CPR track at Dunmore. The deal required that he pay the government only survey charges at 25 cents per hectare [10 cents per acre]. The company also purchased another 4050 hectares [10,000 acres] of coal lands at $25 per hectare [$10 per acre]. Extra miners and labourers were hired, and Lethbridge soon boasted a barbershop, stable, hotel, grocery, and hardware store. Five saloons offered entertainment.

However, the coal market still proved limited, so Galt added a rail line to Great Falls, Montana. Renaming his company the Alberta Rail and Coal Company, he received a subsidy of 1610 hectares per kilometre [6400 acres per mile] for the line.

Early Lethbridge was dependent on Galt mines, but when they were hit by strikes, the town became the site of serious confrontations.

Eventually, the community diversified with farms and market gardens. Here, too, success was tied to the Galts. Not only had Galt built the first hospital south of Calgary, he was the driving force behind southern Alberta irrigation.

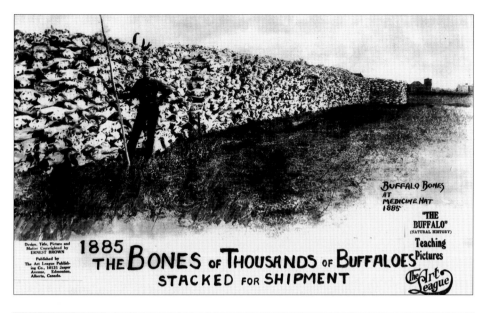

BUFFALO BONES
AT
MEDICINE HAT
1885

"THE BUFFALO"
(NATURAL HISTORY)

Design, Title, Picture and Matter Copyrighted by ERNEST BROWN
Published by
The Art League Publishing Co., 10131 Jasper Avenue, Edmonton, Alberta, Canada.

Teaching Pictures

1885
THE BONES OF THOUSANDS OF BUFFALOES
STACKED FOR SHIPMENT

The Art League

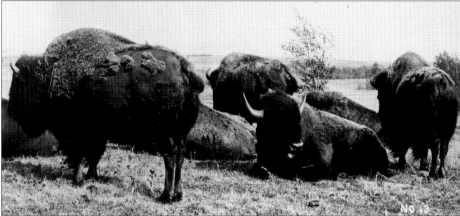

Top: *Collecting buffalo bones became a source of income for settlers. Along the CPR line, at towns such as Medicine Hat and Langdon, bones were piled shoulder high before being shipped to fertilizer markets in the east. Finally, in 1906, the federal government paid $200,000 for 600 privately owned Montana animals near Yellowstone National Park, USA. These were the basis for establishing new Canadian herds at Banff and Wainwright.*

Bottom: *In 1800, about 50–60 million prairie bison roamed North America. Herds could be 32–48 kilometres [20–30 miles] wide. An excellent food source, adult males weighed up to 1000 kilograms [2200 pounds]. By 1885, however, prairie buffalo were threatened with extinction. The wood bison in Northern Alberta were smaller in size and fewer in number, but their isolation helped to protect them.*

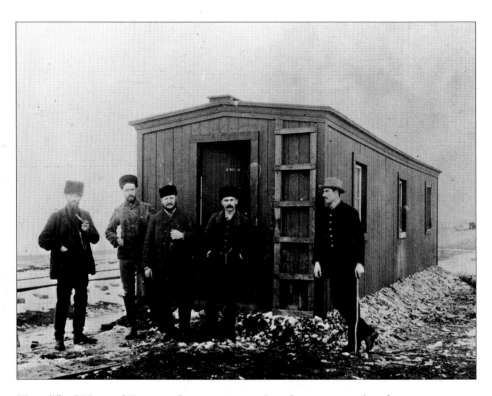

Top: *The CPR saved Fort Calgary from closure. By 1880, only four Mounties were stationed at the fort on the east bank of the Elbow River, and just 75 people lived in the vicinity. Fortunately, surveyors made Calgary a district headquarters. In disrepair, the fort needed to be expanded and rebuilt. Working for the I. G. Baker store, D. W. Davis again received the contract.*

Surprisingly, the CPR chose the west bank as the town site. This rail car became its first station, and a community was soon built around it.

Opposite top: *Speculators and businessmen preceded the railway, setting up tent towns wherever they suspected that the CPR would establish its stations. This photo shows Calgary's first tent town, situated on the east side of the Elbow River. On this occasion, the site selection gamble failed when the CPR chose to locate on the west bank instead. Settlers were prudent, though not necessarily pleased, as they moved their tents, tar-papered shacks, and modest buildings to share in the CPR advantage. The railway was selling lots for $300–$450 with a 50 per-cent rebate for erecting a building within a month.*

Opposite bottom: *A crucial need in new communities was housing. Hundreds of 1883 settlers lived in tents, including throughout the winter. Between 1884 and 1891, Calgary's population grew from 428 to 3876. By 1891, citizens had access to electricity, waterworks, and telephone service. The following year, the town became a city.*

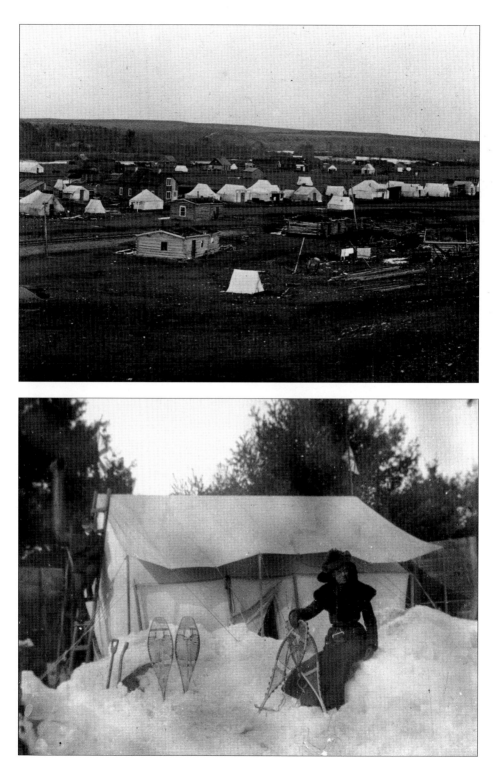

Bottom: *New Albertans were anxious about indigenous people joining the Riel Rebellion. These fears proved unfounded, but ranchers and settlers wanted more protection than could be offered by the small NWMP force. The federal government ordered Captain John Stewart to assemble four militia troops. These became the Rocky Mountain Rangers, Alberta Mounted Rifles, Steele's Scouts, and Calgary's Home Guard. This Ranger wears the unofficial uniform of his troop.*

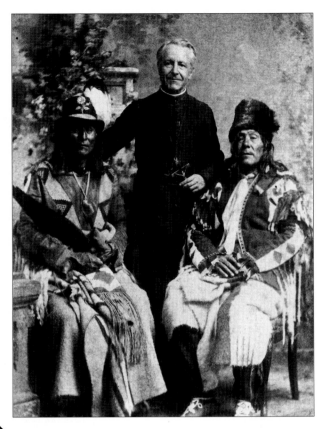

Top: *In 1883 the Blackfoot had refused permission for the CPR to cross their lands. Father Lacombe (centre), who had lived with the Blackfoot and nursed many through illness, successfully negotiated with Chief Crowfoot (left), preventing further conflict and delays. Respecting Lacombe and the NWMP, Crowfoot also discouraged his* *people from joining the 1885 Riel Rebellion. After the rebellion, Crowfoot, Three Bulls (right), and other non-combatant chiefs travelled to Ottawa, were hosted by the government, and had official photographs taken.*

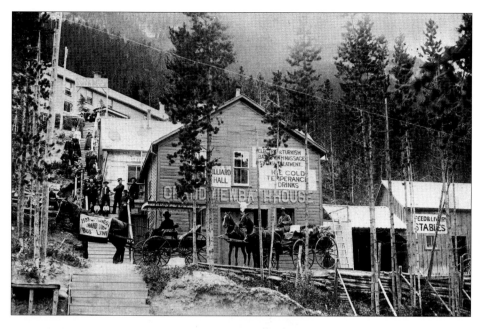

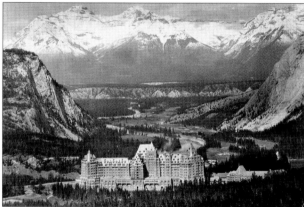

Top: *Once tourists experienced Banff, the love affair never again faltered. Former CPR construction crew surgeon R. Brett, future Lieutenant Governor of Alberta, built two hotels. His Grand View Villa, at the Upper Hot Springs, accommodated 50 guests. Also featuring a pool and bath house, the hotel was served by five carriages called the Hot Springs Grand View Bus Line. In downtown Banff, Brett also built a sanitarium, hotel, and hospital. Hot water for the hospital was piped from the Upper Hot Springs.*

Bottom: *The Banff Springs, the CPR's internationally renowned hotel, opened in 1888. It could accommodate 250 people, but further development was inevitable. A year earlier, legislation established Rocky Mountains Park [later named Banff National Park] as Canada's first national park. By 1902, the enlarged park included 11,396 square kilometres [4400 square miles]. The scenery attracted thousands, and by 1905, the Banff Springs underwent expansion to accommodate 450 guests each night. Six years later the number of Banff Springs visitors for the season was 22,000, but by then legislation had reduced the park to 4662 square kilometres [1800 square miles].*

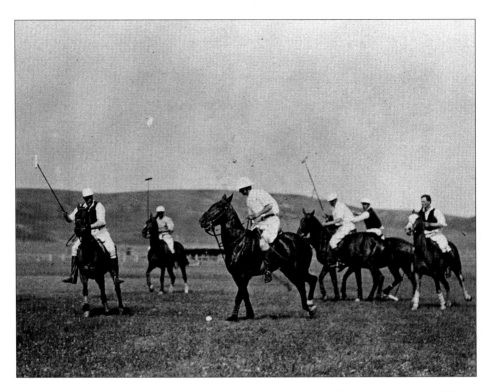

Top: *Since equestrian ability was a requisite skill, frontier polo became a popular egalitarian sport, free of the stigma of social elitism characterizing its pursuit in much of the rest of the world. In this match between Millarville and Cochrane, equipment and attire were standard, but many played their first games with broom handles and cricket ball. A rancher visiting Britain had returned with some equipment and an interest in the sport. From that beginning, dozens of capable cowboys became converts.*

Opposite top: *Many Germans, Russians, French, and Ukrainians sought religious and political freedom in Alberta. Initially settling at Medicine Hat in the 1890s, Galicians [Ukrainians] were soon attracted to Vegreville, Edmonton, and Stony Plain, where soil and climate were similar to those of their homeland. The thatched-roof homes, fur hats for men, and kerchiefs for women, made them a visible minority.*

Opposite bottom: *Various groups seeking religious and political freedom in Canada claimed or purchased prairie land. In 1886, Mormon leader Charles Card (2nd row, 5th left) fled to Alberta to escape polygamy charges in the USA. He and about 40 followers built homes near the St. Mary River. By 1901, their community of Cardston had 639 people, mostly Mormons. Another religious group, the pacifist Mennonites, also immigrated before the turn of the century. Among their first communities was Didsbury.*

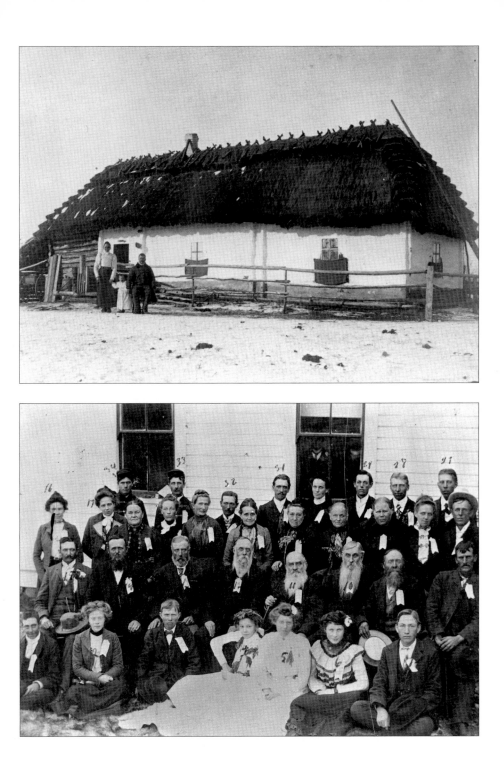

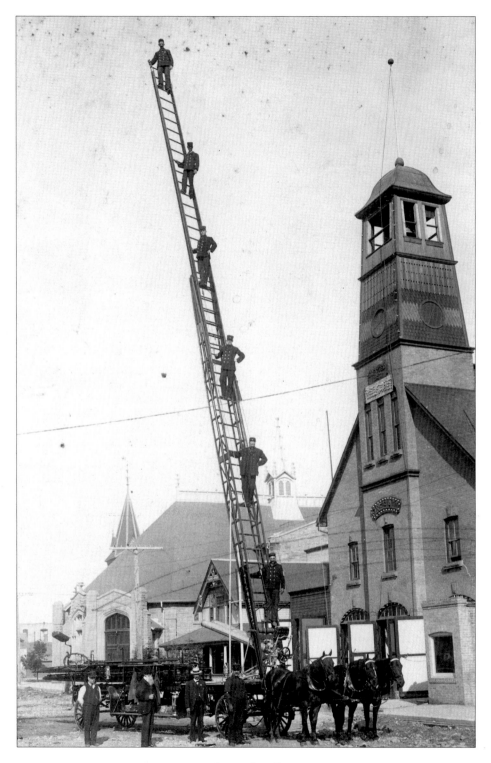

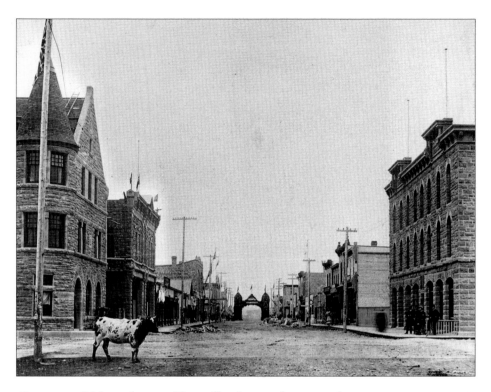

Opposite: *With wooden frame buildings, early Alberta towns could be easily devastated by fire. On November 7, 1886, before proper fire fighting equipment was purchased, Calgary suffered $100,000 in fire damage. With high winds fanning the flames, 18 buildings were destroyed in the downtown area, and many others were damaged. A year later, Firehall #1 (left) was erected, and volunteer fire fighters were on call.*

Top: *After the 1886 fire, a new Calgary, the Sandstone City, took shape. A brick factory and a sandstone quarry had existed in 1886, but with the growing demand, other quarries opened. Sandstone was hewn from the banks of the Bow and Elbow Rivers, and from near Nose Creek. In some locations, it was six feet thick. With massive deposits and top-notch workmen available, the Sunny Side Quarry entered a sandstone bassinette in the 1896 Chicago World's Fair. It had to be sent by rail on a flatbed, but the entry won a medallion. Over a period of*

about 30 years, excavating sandstone and crafting it as a building material created jobs for half of Calgary's tradesmen. Quarries near Cochrane and Okotoks provided similar employment opportunities for those communities. Eventually sandstone gave way to brick, and with improved firefighting equipment, lumber once more became popular.

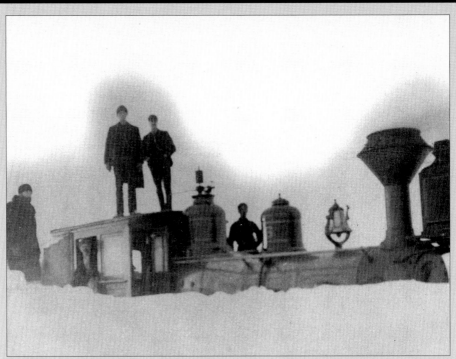

FOR SETTLERS spread across vast tracts of Alberta landscape, fires and severe winters were the worst threats. In some areas, such as the chinook belts in southern Alberta and near Lesser Slave Lake, being snowbound was often merely a temporary inconvenience, as chinook winds could raise temperatures by over 30 degrees Celsius [in excess of 50 degrees Fahrenheit] within hours. However, throughout most of the province, January temperatures and heavy snowfalls created havoc and hardship.

After a two-week blizzard in February 1887, these Lethbridge employees of the Alberta Rail, Coal and Irrigation Company dug the company's Engine #6 out of snowdrifts near Winnifred. Twenty years later, in the Lethbridge area, the death toll for livestock soared when blizzards unleashed heavy snowfalls, and deep-freeze temperatures persisted longer than usual.

An even more alarming possibility was that of fire in mid-winter. Early communities had limited fire fighting equipment and access to water. At Fort Saskatchewan, on January 18, 1901, the results were devastating for the Farmer's Milling Company. Although some equipment was available from the NWMP barracks, lack of water meant that volunteers watched the mill burn to the ground. Unable to recoup losses, the company folded by spring.

Top: *The Calgary Milling Company, later named Robin Hood Mills, was built in 1898–99. Six years earlier, local carpenters and joiners had formed a union. It had pressed for a nine hour day,* *but the brotherhood lasted only a year and did not resurface until about 1902. Meanwhile, the construction industry boomed. Needing income, many new immigrants accepted work as skilled* *craftsmen and labourers regardless of conditions or wages. Railway employees and miners were more successful in early efforts to unionize.*

Top: *Edmonton's growth was accelerated by the arrival of prospectors. In 1897, these men, like many others, hoped to wash gold from the North Saskatchewan River. Some prospectors used the old-fashioned method of panning, while others employed sophisticated dredges anchored in the middle of the river. This system was called a "grizzly."*

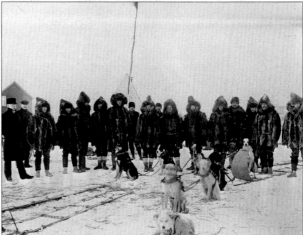

Bottom: *During the Klondike Gold Rush at the century's end, prospectors streamed into Edmonton, gateway to the north for the all-Canadian route.*

Businesses were happy to outfit them for hefty fees, and Klondikers departed in every imaginable contraption and conveyance. Few were as practical as those of this par-

ty. Reaching the Peace River Country, many prospectors gave up, turned back, or settled rather than facing further hardship.

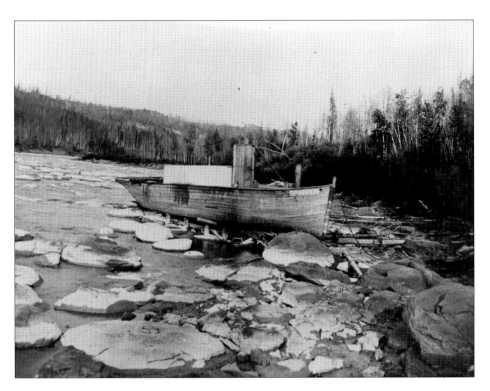

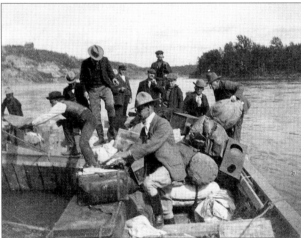

Top: *During travel on Alberta's northern rivers, scows and boats often had to be tracked. Once a rope had been attached, men on shore guided the boats through rapids or pulled them against strong currents. Early river travel also involved other risks including low water, high water, and ice. In 1899 the steamer* Sparrow *was wrecked in the ice at the Grand Rapids on the Athabasca River.*

Bottom: *Many gold rushers came into conflict with aboriginals and Metis. Some prospectors claimed aboriginal land when seeking to settle permanently. Others were party to alcohol-related problems, or used poison bait, inadvertently killing community dogs. Such difficulties precipitated Treaty 8, signed in 1899 with Wood, Cree, Beaver, Chipewyan, and Slave nations. This scow was loaded with treaty scrip and goods, but the latter frequently found their way into the hands of speculators.*

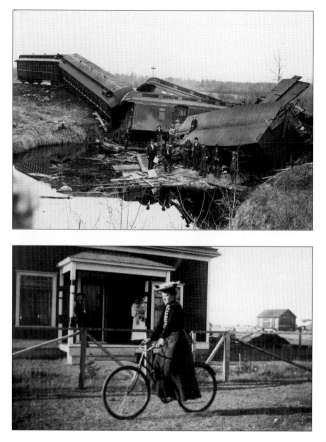

sible. *After what seemed like an endless wait to Edmontonians, the CPR finally completed a railway between Edmonton and Calgary in 1891. To the dismay of Edmontonians, the track did not cross the North Saskatchewan River, but instead ended at a Strathcona station. This 1899 wreck, including passenger cars, occurred south of the station. The first locomotive crossed the river on October 20, 1902. It belonged to the Edmonton, Yukon, and Pacific Railway.*

Bottom: *Not only necessities, but everything from windmills to baby carriages, could be ordered from the catalogue and shipped by rail to new communities. When money was available, luxury items such as bicycles filled out the orders and became birthday or Christmas presents. Bicycles advertised for children, ladies, and gents in the 1902 Sears Roebuck Catalogue cost about $9 to $16. They possessed single or double tube tires. At the same time, Eaton's offered only tricycles for girls up to age 15. The more sturdy velocipedes were advertised for males. Both had iron wheels.*

Top: *The CPR's trans-Canada line ran through Calgary, but the rest of the province desperately needed transportation links. Already, in 1883, stagecoach service existed between Fort Calgary and Fort Edmonton, but a one way journey took five days. The $25 price tag included four nights at stopping houses. Travellers were entitled to 45 kilograms [100 pounds] of luggage each, and they could expect the unexpected. If the coach rolled through mud in Calgary, it might need sleigh runners for the last leg of the trip approaching Edmonton. And bandits were a very real risk.*

Generally, only relatives of those already living in the two communities, and those intent on establishing businesses or professional practices, took the north-south stage. Before train service, most settlers travelled in their own wagons.

With rail links, far more extensive settlement became pos-

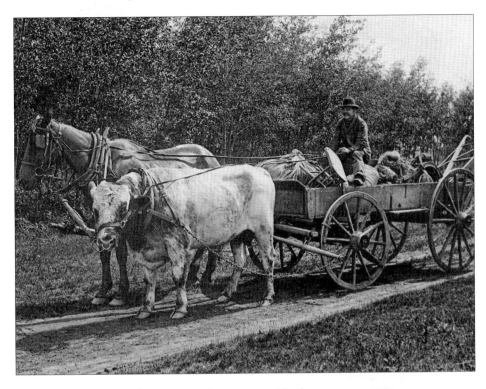

Top: *Many pioneers with limited financial resources recognized that one horse and one cow would be more useful than two of either animal. The plow (seen loaded at the back of the wagon) was another essential. Most families piled their wagons high with household goods, farm equipment, and staple foods. Having so few possessions, much of this newcomer's success would have been dependent on his optimism, perseverance, and survival skills.*

Bottom: *Chinese labourers laid off by the CPR in the 1880s sought work as cooks at ranches, mines, and lumber camps. Others opened restaurants and laundries. Still, only 31 Chinese lived in Alberta in 1891. The most serious early incident involving discrimination occurred in 1892. A returning resident had contracted smallpox while abroad. Hysteria resulted in abuse, and the vandalization of two laundries. The 80 Chinese men living in Calgary in 1900 made it Alberta's largest Chinese community.*

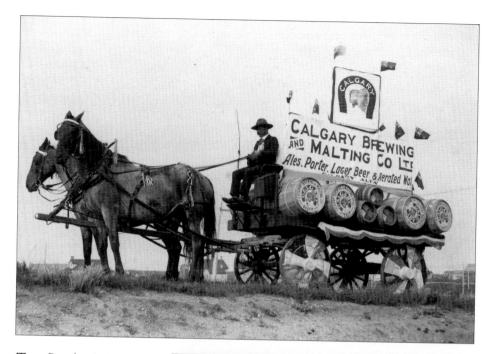

Top: *Rancher A. E. Cross founded the Calgary Brewing and Malting Company. It produced its first malt in 1893. Involved in a wide variety of business ventures, Cross bought many hotels, and their licensed premises guaranteed success for the brewery. By the 1900s, the Alberta company was already marketing in Saskatchewan. This delivery wagon was used in Melville.*

Bottom: *In the late 1800s, the importation, manufacture, and sale of alcohol was allowed only by special permit. Protest led to licensing and legal sale to whites but not to native people. Until the 1900s, it also remained illegal to have alcohol at railway camps. Establishments near such camps were called blind pigs since the booze was smuggled there in pig carcasses.*

Pat Burns

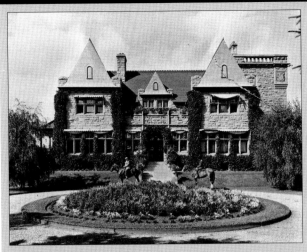

MILLIONAIRE rancher and meat packer Pat Burns had this eighteen-room Calgary mansion built in 1901. Renowned architect Francis Rattenbury designed the Burns' home, but its owner had modest beginnings.

An Ontario farm boy with little education, Burns moved to Winnipeg and worked for other farmers and cattlemen. Finally, he won his own contract to provide beef to a CPR construction crew. As railway crews moved farther west, so did Burns; and in 1890 Alberta became his home.

Burns continued providing meat to the CPR, and garnered a contract to supply the Blood Reserve. By 1891, he had begun shipping beef to British Columbia. During the Klondike Gold Rush, Burns also opened butcher shops along the route to the Yukon.

When he purchased William Roper Hull's Bow Valley Ranch and retail meat shops in 1902, Burns was already feeding about 10,000 cattle. He expanded the Bow Valley Ranch and used it as a staging area for his other operations. By 1904, he was feeding about 30,000 head.

Within eight years, Burns was involved in six Alberta ranches. At various times, he owned or held the grazing leases of the Bar U, Walrond, Olds, and CK Ranches, as well as the Ricardo Ranch near Shepard, the Mackie spread near Milk River, and the Imperial Ranch near Big Valley. People claimed Burns could ride from the international border to Calgary without leaving his own land.

Not surprisingly, he became known as Canada's Cattle King. In 1928, at time of sale, Burns' meat packing operation was worth $15 million and had outlets in Canada, Britain, and the USA. A representative was also courting the Japanese market.

Burns was a shareholder in grain elevators, trust companies, banks, and life insurance companies, but most people considered him a personable, humble, and generous man.

During the 1931 Stampede, Calgary held a gala celebration to honor Burns' 75th birthday. At this event, his appointment to the Senate was announced. As a thank-you to his hosts, Burns donated meal vouchers for 2000 destitute men and provided 2000 roasts of beef to the needy.

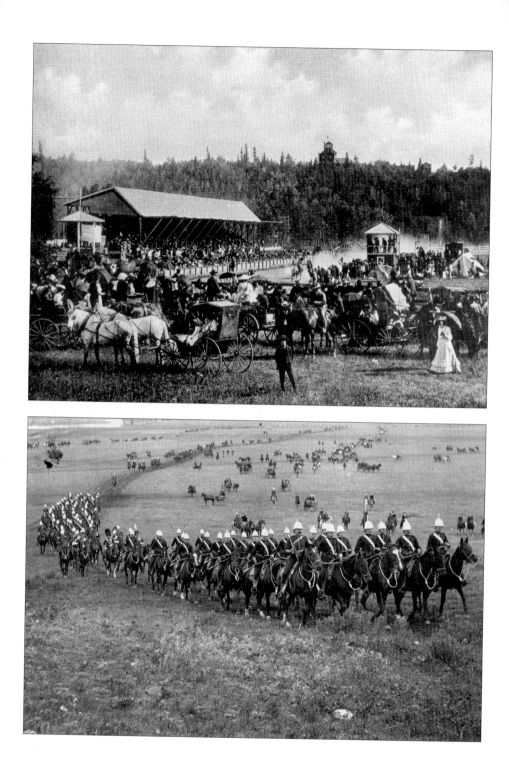

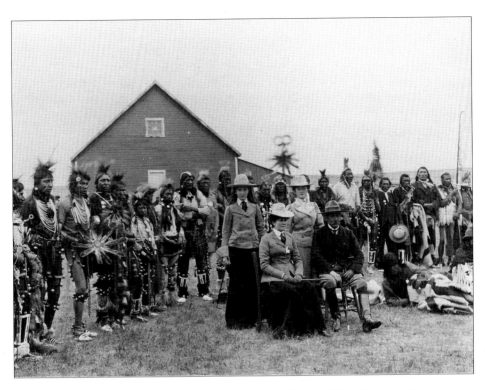

Opposite top: *May 24 and July 1st were slated for fairs and sports days. Already in 1879, with a population of 700, Edmonton had established an agricultural society and held its first fair. Combining displays with popular events such as baseball, trapshooting, foot races, and horse races attracted even larger crowds. In 1884, Edmonton's Dominion Day events drew 300. By 1899, 3000 were attending the celebration in the river flats, site of these 1904 festivities. Borden Park Exhibition Grounds opened five years later.*

Opposite bottom: *The NWMP (later to become the RCMP) have been featured in Alberta parades since shortly after their arrival in the province. For the 1901 visit of the Duke and Duchess of Cornwall and York, the Mounties paraded across the prairie to Shaganappi Point, Calgary. Mountie bands were first formed in 1870, and one was present at the signing of Treaty 7. Riding displays, including some with music, evolved by the late 1880s. The Musical Ride, formalized for public entertainment, dates from 1904.*

Top: *In 1900, Governor General Minto and his family visited this Blackfoot reserve. For the occasion, some wore black suits (right). One man (left centre) wore a kilt, while others donned more traditional costume. With the blending of cultures, even ceremonial dress had begun to reflect two worlds.*

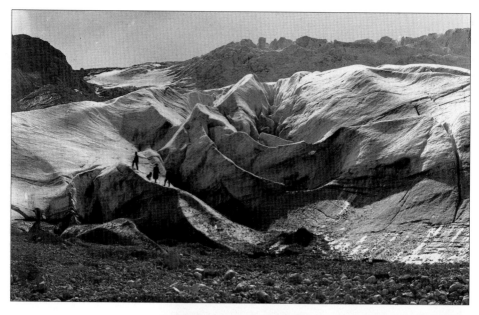

Top: *The birthplace of the South Saskatchewan River system was discovered in the upper Bow River Valley. The Bow's lake, pass, and glacier were explored by Tom Wilson, James Hector, and Walter Wilcox. Glaciers in the Rockies were of special interest to Philadelphia's Vaux family, whose annual photographs and measurements constituted Canada's first continuous glacier study. In this 1902 expedition, they focused on the Bow Glacier.*

Bottom: *The era of the automobile had dawned, but in the mountains and northern areas, rails and roads were slower to arrive. Pack trains were still the primary mode of*

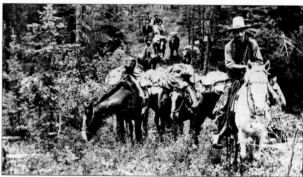

travel. Derek Hunter (above right) was chief packer for Grand Trunk Pacific during the building of its railway. Some of Alberta's other best known outfitters, guides, and packers were Tom Wilson, the Brewster brothers, Jimmy Simpson, and Bill Peyto. Most of their work was for the railways, government surveys, logging companies, mountaineers, and tourists.

Opposite: *In 1902, Professor J. Norman Collie's expedition tackled Mt. Neptuak. Neptuak was peak nine in the dramatic Valley of the Ten Peaks, near Lake Louise. The valley was discovered by Walter Wilcox three years earlier. Using the Stoney language, he named the peaks as numbers one through ten. In 1897, Collie had been among the first to conquer Mt. Lefroy and Mt. Victoria.*

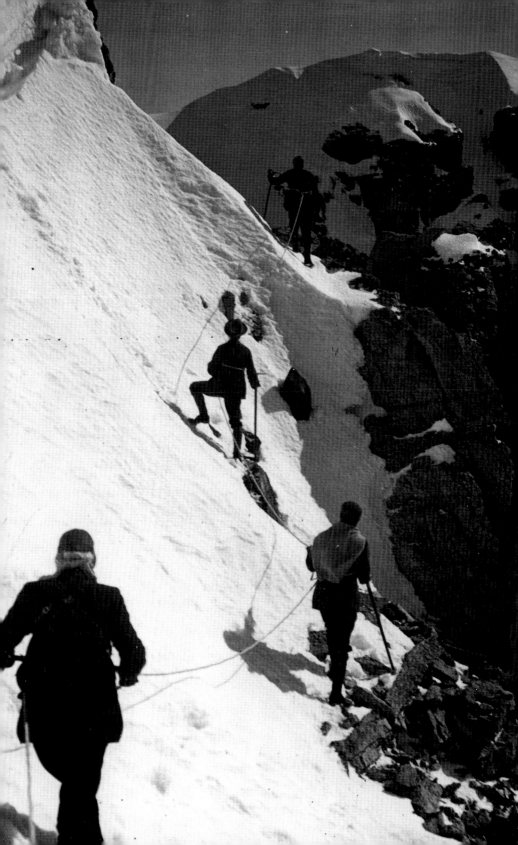

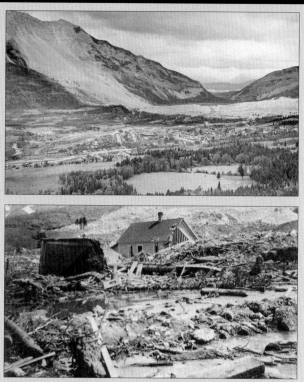

ON APRIL 29, 1903, disaster struck in the Crowsnest Pass. The shale and limestone north face of Turtle Mountain, towering over the town of Frank, broke away. The massive rock slide occurred at 4:10 a.m. and lasted slightly less than two minutes. Ninety million tons of rock buried two ranches, a coal mine, and homes on the east side of Gold Creek. About 100 people were caught in the path of the slide. There were 23 survivors. Seventy-six were presumed dead, but only 12 bodies were recovered.

The slide created flooding, fire danger, and loose rock. Massive boulders continued to rumble down the mountain, and as an extra precaution, families in locations untouched by the slide were also evacuated.

Miners working the night shift had been entombed by the disaster. Immediately, rescuers began rebuilding an entrance to the mine. Finally, breaking through the wall of rock, they saved 17 men.

In the middle of the slide area, the CPR track was buried by debris as high as a locomotive. While rock was dynamited and cleared for a new rail line, the CPR offered travellers a stagecoach detour to the other side of the slide path. Mail was transferred from train to train by the Mounties. Eventually, rail travel though the pass was re-established, and some of the unwanted rock was freighted to Winnipeg and Vancouver for ballast in bridge building.

The mine workings also reopened. The main tunnel had not been damaged beyond repair, but about $75,000 worth of work was required.

The town of Frank survived, and a new kind of visitor arrived. Curious travellers, geologists, historians, and photographers would ever after stop at Turtle Mountain, where a mountain face had sheared and a community remained buried under rock.

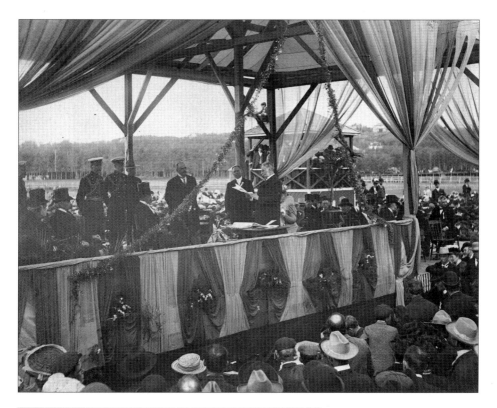

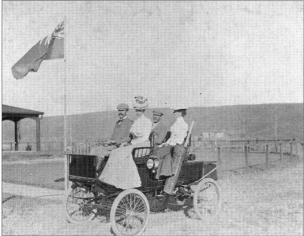

after the First World War. As more people acquired cars and trucks, tourism increased.

Top: On September 1, 1905, Edmonton hosted the official inauguration of Alberta as a province. The city became the capital, and A. C. Rutherford was named premier. Prime Minister Sir Wilfrid Laurier and Governor General Earl Grey joined the 12,000 to 20,000 Albertans attending. Celebrations included a parade, a rally, and a formal ball at the Thistle Rink. Beer was free.

Bottom: Alberta's first car, a Stanley Steamer, was owned by Senator Cochrane. Its arrival in 1902 was followed by John Prince's Rambler, which burned gasoline. J. H. Morris purchased Edmonton's first car in May 1904, but cars were not readily affordable for most until

Faces From Afar

As high-speed highways of the past, railways determined community locations. By the 1900s, private steamship and railway company colonization plans, as well as a federal government campaign, targeted Europe with the promise of prosperous homesteads. Powers and rights granted to the governments of new provinces became an additional selling point and contributed to phenomenal growth before the First World War.

Many colonization associations held vast blocks of Alberta land. Farm immigrants were eligible for homesteads, but both they and other prospective Albertans could also buy land from the associations. As a result, Old Country friends and relatives gravitated to the same areas, creating ties of ethnicity in their new communities.

A French immigrant founded Trochu, but most of the Alberta towns with French names, such as Leduc, were founded by Oblate missionaries. Jewish settlements were established at Rumsey and Trochu. Many Norwegians chose Claresholm; Swedes moved to Stavely while Finns settled at Wetaskiwin and Red Deer. The central Alberta communities of Stettler, Botha, and Donalda had roots in Germany, Switzerland, and the USA. Christian Dutch Reformers, seeking to practise their beliefs without interference, settled the Monarch, Granum, and Nobleford areas. Other religious groups, including Mennonites, Hutterites, and Doukhobors, eventually sought the same freedom in Alberta.

Edmonton, Vegreville, Stony Plain, and Fort Saskatchewan became home to large numbers of Ukrainian farmers and miners. Other Eastern Europeans also found work in the mines of Lethbridge and the Crowsnest Pass. They brought both their skills and their support for unions and co-operative ventures. With mines employing six percent of non-agricultural workers between 1898 and 1912, they had a significant impact on the evolving identity of Alberta.

The two largest immigrant groups, the British and Americans, had a powerful influence on culture and education. Along with English-speaking, Canadian-born settlers, they made up over half of the pre-war population. The third largest group, comprising one in ten Albertans, was from a German-speaking culture, but assimilation by English-speaking cultures was almost universally expected and accepted.

By 1903, the era of the steam threshing machine and correspondingly larger farms meant that farm labour was in demand. Immigrants seeking to eventually establish their own businesses or farms readily found work, and many remained in farm communities. By 1905, with an 80 percent rural population, Alberta

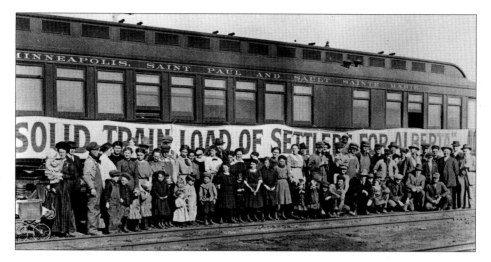

dubbed itself the Granary of the Empire.

Responding to the demand, services expanded. Already, in the 1880s, the *Edmonton Bulletin*, *Macleod Gazette*, and *Calgary Herald* had issued their first editions. By 1906, many small communities had well-established weekly newspapers, health and banking services, blacksmith and livery stables, and specialty and general stores.

Although growth remained strong, it began to peak within the next decade. The proportion of immigrants from the various homelands was little changed. Eighteen percent were British-born. Twenty-two percent immigrated from the United States, especially the Midwest, but many of these Americans had begun life in Europe.

Born into slavery, John Ware was the first black American settler in Alberta. As a cowboy working a cattle drive into Alberta from Idaho, Ware decided to bring his wife and children. Years later, their Millarville farm would become an historic site, but they were only one family amongst a thousand other black American pioneers arriving before the First World War.

The first settlements had been along the north-south corridor from Edmonton to Calgary, but eventually other locations attracted attention. However, much of Alberta was experiencing 80 or fewer frost-free days. Only with the distribution of the early-maturing Marquis wheat and the building of branch line railways did regions such as Edson, Grande Prairie, and Peace River attract settlers.

Top: *Trains brought hundreds of settlers from the USA. Here, a Colorado group has arrived in Bassano. At some stops, community boosters and real estate agents wooed prospective citizens, especially during the peak settlement period from 1905–1914. By 1911, twenty-two percent of Alberta's population had immigrated from the USA. About half the population had a British heritage, while those with Eastern and Central European backgrounds comprised twelve percent. Scandinavians numbered about eight percent, and the remainder came from various countries.*

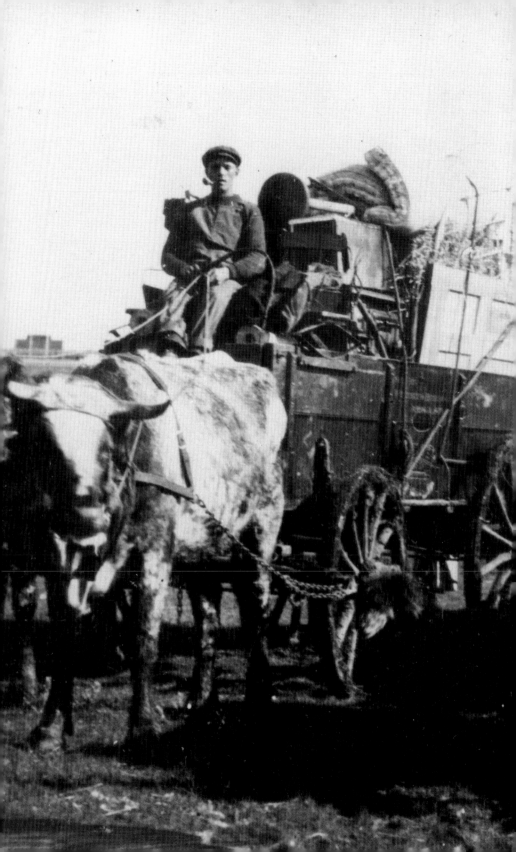

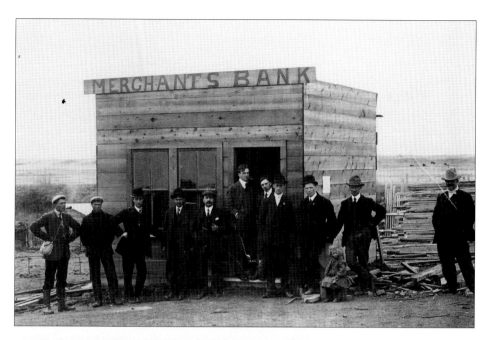

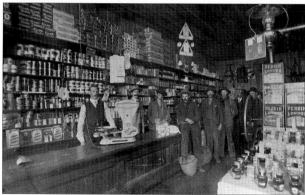

lawyer, and two druggists. The population was 700. The Merchants Bank was one of two banks when the community gained status as a village.

Bottom: As in this High River general store, most early Albertans were males between 20 and 35. Throughout the West, from 1891–1911, men outnumbered woman at least 118 to 100. In many communities, the imbalance was even greater. On Calgary streets in 1911, there were 155 men to every 100 women. Hearing of the shortage, the British Women's Emigration Association encouraged gentlewomen to relocate to Western Canada.

Opposite: For a $10 registration fee and the commitment to build a home, the Dominion Lands Act entitled males over 21 or the head of a household to one free quarter section of land. After living there three years, settlers could buy another quarter of crown land. In the meantime, speculators were purchasing huge tracts from the railways. As a result, in Calgary, prime lots jumped to $200 in 1906. By 1912, the same lot was selling for $2000.

Top: Buildings in the new communities might have rough exteriors, but business was brisk. One year from the construction of its first building, Stettler had 70 businesses, two doctors, a dentist, a

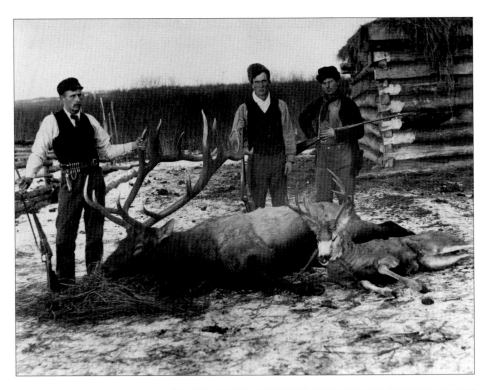

Top: *Hunting was not simply a hobby but a necessity for many pioneers. Here Ross Creek hunters pose with a large elk and small deer they have bagged. Where beef was not readily available or was very expensive, game became a staple food. Antlers were used as decoration for homes and tourist facilities. Hides provided clothing, sleigh robes, and rugs.*

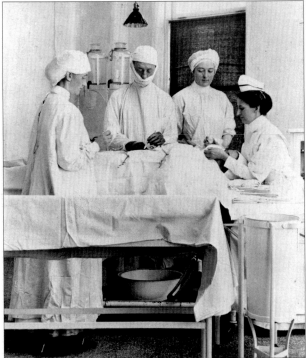

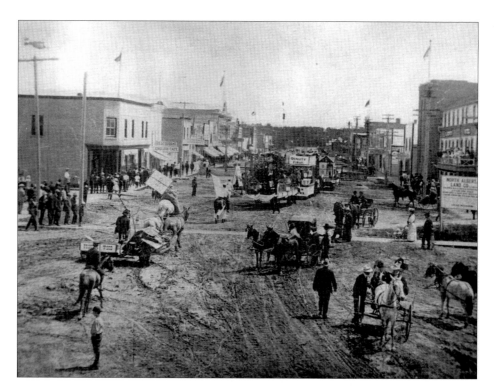

Opposite bottom: *To permit surgery to be performed in Calgary's first four-bed hospital, workers converted the dining room into an operating room. By 1898, when Marion Moodie became the first nurse to graduate at the Calgary General Hospital, the community had a 21 bed facility. Moodie chose to work as a visiting nurse, while these 1905 colleagues assisted with surgery in the new operating room at the General Hospital.*

Top: *The Red Deer region experienced phenomenal growth between 1904 and 1905. During that period, when homestead registrations at the Dominion Land Office increased by 161 percent, Red Deer became the fastest growing community in Canada. The 2334 registrations for 1904/05 skyrocketed to 4025 by September 1906.*

Next page: *In public schools, many children were second language students. As well as teaching them English, instructors were expected to convey British-based Canadian traditions and to encourage nationalism. Because of a teacher shortage, Normal Schools were established so that educators might be trained locally. In 1907, the average teacher's salary of $600 was low compared to that of other professions. Many unmarried women were employed at rural, one-room schools. Marriage disqualified them as teachers.*

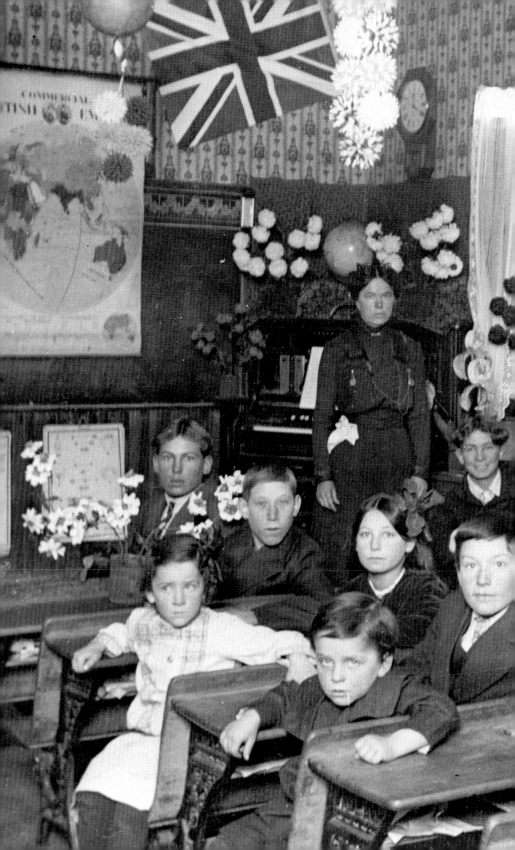

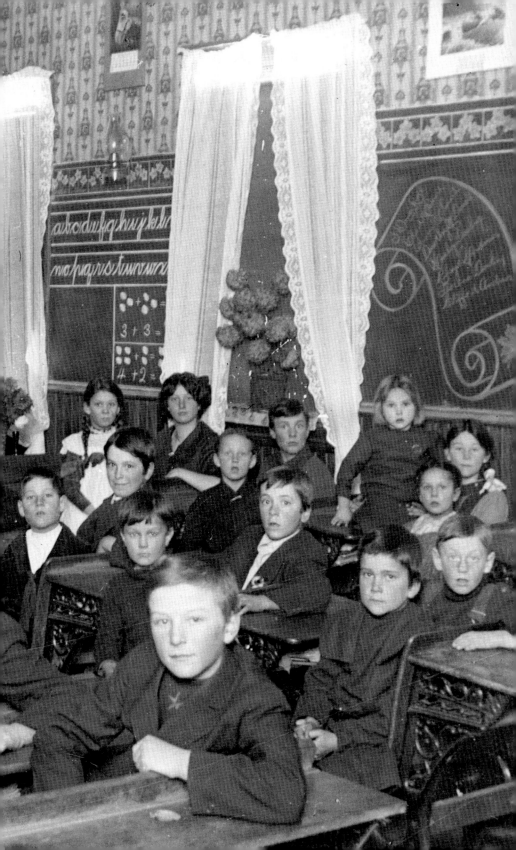

EDMONTON and Calgary waged a fierce battle over which would be home to the University of Alberta, but Edmonton prevailed. In 1907, Strathcona [South Edmonton] received the nod to purchase 104 hectares [258 acres] for the campus of the first university to serve the surrounding 647,450 square kilometres [250,000 square miles]. Dr. Henry Marshall Tory, a McGill physics professor, was appointed president, and he recruited four other professors to teach classics, engineering, English, math, and modern languages.

In 1908, the first U. of A. classes were held at Strathcona Public School. The 47 full and part-time students, including seven women, gave Edmonton the honor of having the highest enrollment in the first year of operation of any Canadian university. Green and gold were chosen as the university's colours. Green symbolized optimism and represented spruce forests and lush parklands. Gold stood for harvest fields and the light of knowledge.

Fraternities formed. The seven female students called themselves the Society for Independent Spinsters [S.I.S.], a forerunner of the Wauneita Society. By 1911 the first campus building, Athabasca Hall, opened its doors, providing a dormitory, classrooms, and library all under the same roof.

That year a few students with advanced credits graduated, and the next year, degrees were granted to the first class completing all course work at the U. of A.

In 1912 the university expanded. A Faculty of Law and a Department of Extension were added to the arts, science, engineering, and agricultural programs. Extension services provided speakers, advice, information, and agricultural research bulletins to rural communities. By the end of the First World War, the university was also offering degrees in commerce, dentistry, pharmacy, household economics, and graduate studies. In 1928, 1600 students attended classes in six campus buildings.

In the meantime, Calgary had established a private university, Calgary College. When denied degree-granting status, it closed. Not until decades later did Calgary open the second university in Alberta.

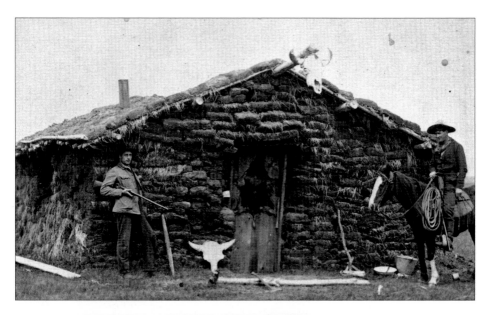

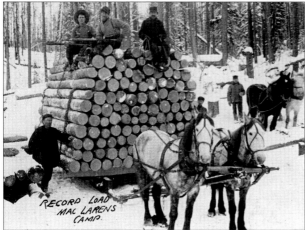

Top: *In dryland rural areas such as Haneyville [Coronation], some homes were very basic as late as 1907. With neither trees for lumber nor a nearby railway or river for shipping, people built shelters from the only locally available building material, sod. Usually, settlers lived in sod houses for only a year or two, until they had money and material for a better home.*

Bottom: *The construction industry had moved ahead full-throttle since the early 1900s. As a result, lumbering along rivers, near the mountains, and farther north became increasingly important. MacLaren Lumber operated near Pincher Creek. Another company was similarly en-* *gaged at Barrhead. Eau Claire logged along the Bow River, and its Calgary mill employed many Norwegians. At the same time, conservation efforts were experiencing success, and the federal parks system and forestry reserves were expanded between 1907 and 1911.*

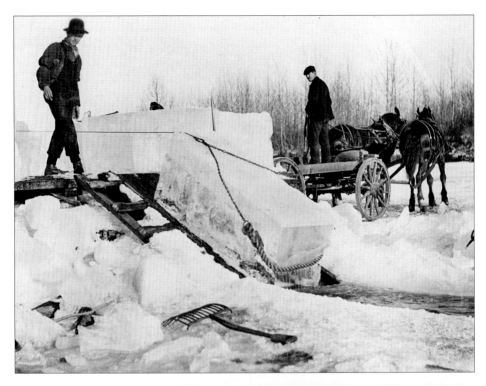

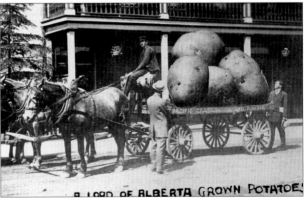

A LOAD OF ALBERTA GROWN POTATOES

Top: *During winter, ice was cut and hauled from rivers or lakes. Properly stored in underground cellars, it could be used from spring to fall for domestic and commercial purposes. In towns, ice could be purchased from ice-wagon vendors for home use. Although many homemakers canned hundreds of jars of meat, vegetables, and fruit, small ice chests were the refrigerators of the day for perishables.*

Bottom: *Proud Albertans have long enjoyed their claim to being first, biggest, and best. From pioneer days, they were prepared to support their boasts even with trick photography. But the pride originating from the agricultural community was eminently justifiable. By 1914, farmers comprised 62 percent of the provincial population. Although known internationally for grain production, they also developed viable sugar beet and market gardening farms in southern regions, as well as successfully adapting to conditions in northern areas.*

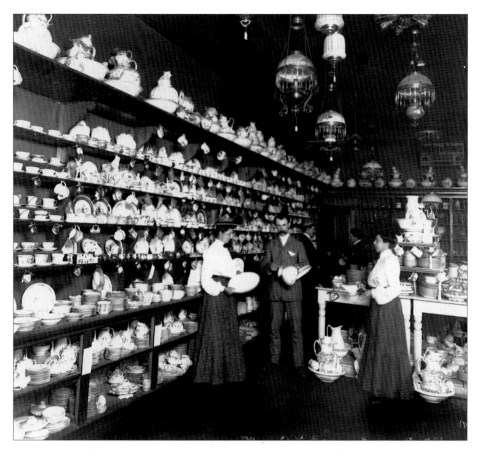

Top: In turn-of-the-century Alberta, ordinary glass tumblers cost 50 cents to a dollar per dozen. Those shoppers who lived in large communities, however, had access to more exclusive housewares. A 100 piece set of fine china could be ordered from Eaton's Catalogue for $13–$30, but local prices such as those at Edmonton's Revillon Freres were generally much higher.

As early as 1912, those who wanted to purchase Alberta-made pottery could look to the new factory in Medicine Hat. With the Medalta line, the community became the pottery manufacturing centre of the west. As one of only two locations in North America where quality stoneware clay was available, Medicine Hat's products were in demand. The stoneware clay had a high silica content,

making Medalta pottery stronger than earthenware. As a vitrified pottery, once fired, it was waterproof even before being glazed. By 1921, Medalta was shipping to markets east of the Lakehead, making it the first prairie manufacturer to break into eastern markets.

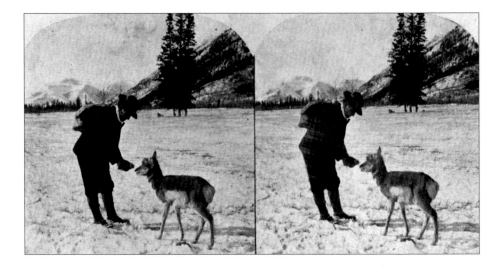

Top: *To simulate a three dimensional world, double images were printed on postcard-style cards, which were then mounted on a stereo viewer as a popular form of home entertainment. Scenic Alberta stereo cards, such as this one of a hiker feeding an antelope in what is now Banff National Park, attracted sightseers and were an early hit as tourist mementos.*

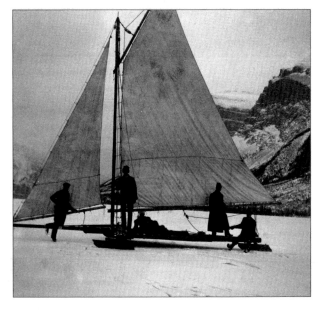

Bottom: *Its native names hold frightening connotations. Cannibal Lake, Dead Lake, Devil's Lake, Ghost Lake, and the Lake of the Evil Water-Spirits are all names for the Lake Minnewanka playground. Not only does it provide good fishing, canoeing, and hiking in summer, but in winter the largest lake in the park metamorphoses into a wonderland ideal for ice boating.*

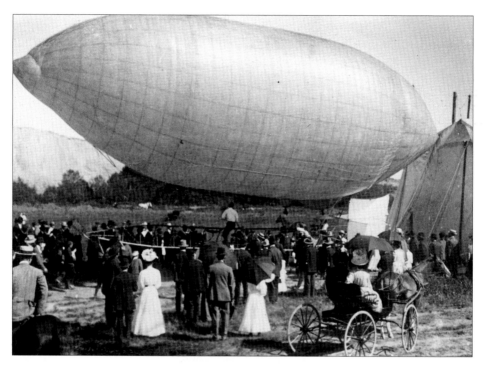

roads were two primary reasons why northwest Alberta had a population of only 5000 prior to 1912.

Top: *Fairs and agricultural exhibitions often featured the latest technological wonders. In 1906, Calgarians marvelled at their first sighting of a hot air balloon overhead. Two years later, the hydrogen-filled Strobel's airship made five flights over Victoria Park as part of the Calgary Exhibition. Minutes later, a shocked crowd witnessed it catch fire, leaving only rubble in the aftermath.*

Bottom: *The town of Slave Lake on Lesser Slave Lake might be 850 kilometres [530 miles] from Edmonton over present-day roads, but in 1907, it was not in any way lacking festive opportunities. Mounties and local residents, most of them native, joined in celebrating Dominion Day. Before a railway link was established, muskeg and muddy*

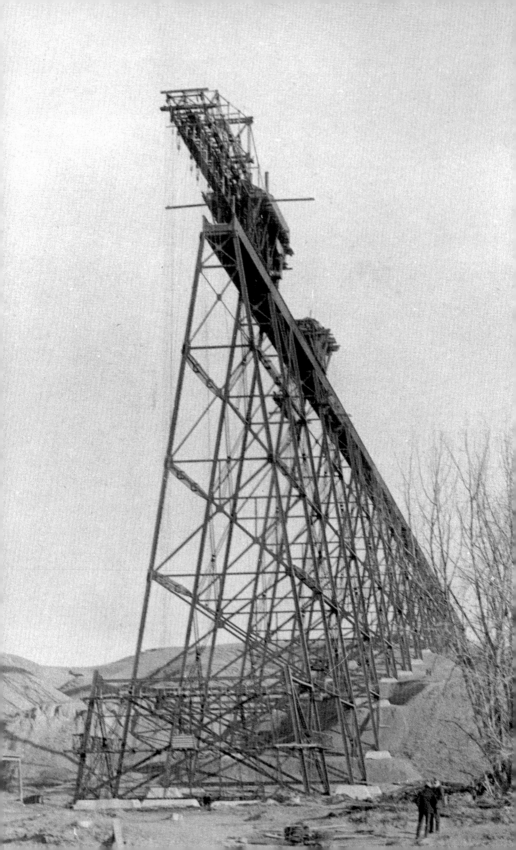

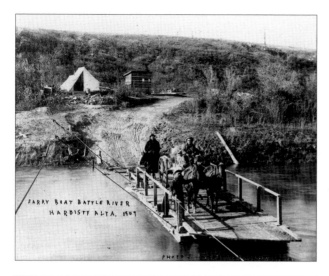

FERRY BOAT BATTLE RIVER
HARDISTY ALTA. 1907

Top: *Despite an increasing number of bridges, most travellers still crossed Alberta's rivers on small or large ferries. On the Battle River near Hardisty, a simple platform-style ferry was attached to cables and shuttled people, wagons, and goods. Settlers followed the river east from Ponoka and Wetaskiwin. At Wetaskiwin's Alberta Hotel, travellers paid 25 cents for a room and the same for a meal. Local lumbering companies floated logs and lumber downstream to build the communities.*

Bottom: *Cresting at 8.1 metres [26.7 feet], the 1908 flood of the Oldman River complicated bridge construction. Underwater caissons of 25 by 25 centimetre [10 by 10 inch] timbers, weighed down by rail ties, were deployed to accommodate concrete forms. When these became flood damaged, divers removed the debris before the concrete was poured. The workman at the pump, circulating air to divers, was paid 22 cents per hour. Cement for the project came from Exshaw and Calgary.*

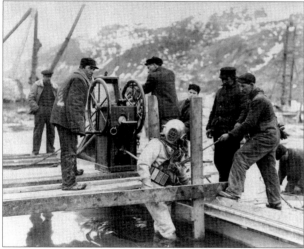

Opposite: *Constructing the CPR bridge over the Oldman River at Lethbridge challenged both engineers and builders. Deep coulees necessitated a bridge 1.57 kilometres [1 mile] long and 91 metres [300 feet] high. It needed to withstand extreme temperature changes and extreme winds. During construction, three workers and two trespassers died, but in 1909, the bridge was touted as a wonder of the world by western newspapers. At the time, it was the highest and longest of its type.*

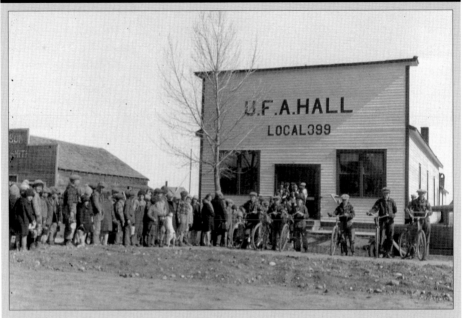

COMMUNITIES were taking shape throughout the province, and so was political thought. Settlers arriving from other provinces, Europe, and the USA had diverse backgrounds but seemed to hold one belief in common. In their new home, independent-minded Albertans wanted legislators who were responsive to the needs of constituents rather than ones who toed the line for the old parties. So began a unique political history of landslide victories and defeats for a succession of political dynasties.

The first truly successful protest party in the province was the United Farmers of Alberta. Formed in 1909, the UFA became increasingly popular in rural ridings as a political alternative. While the ruling Liberals were defending themselves in a railway scandal, the UFA built community halls such as this one at Enchant. By 1915, under the leadership of Henry Wise Wood, the party had a platform focusing on farm economics, grain marketing, and Western alienation stemming from federal policy decisions.

The UFA also supported free trade, women's rights, and decentralized government. With farmers as Alberta's major economic force in 1921, the party swept the provincial Liberals from office. Of its 44 candidates, 38 were victorious, giving it the majority in the 61 seat legislature. The party remained in office until personal scandal forced the UFA premier to resign. The problems of the Depression created conditions for the formation of the next Alberta protest party, Social Credit.

In Lacombe, as elsewhere, these men knew that electricity would mean new types of jobs and would change the way in which people viewed their world. Electrical power had been introduced in Edmonton and Calgary in the late 1880s, but it was 1911 before the first power line was built. The realization of long distance transmission of up to 55,000 volts eventually revolutionized rural homes and workplaces.

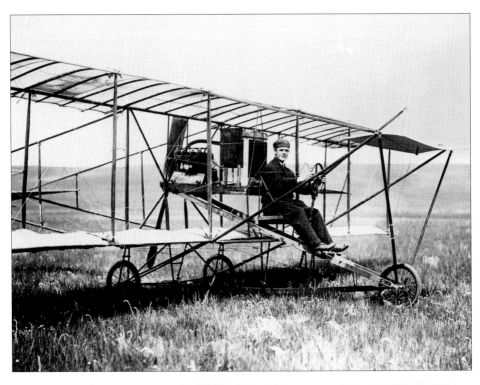

Top: *The three Underwood brothers, who lived at Kreugerville near Stettler, created and flew the first manned kite in Canada. The first heavier-than-air machine to fly in Alberta lifted off in 1909. Carpenter Reg Hunt was airborne 10–15 metres [30–50 feet] above Edmonton homes for 35 minutes. Calgarians saw their first plane in 1911. This biplane, called West Wind, was part of the Ellis operation and was based in the Shouldice community in Calgary.*

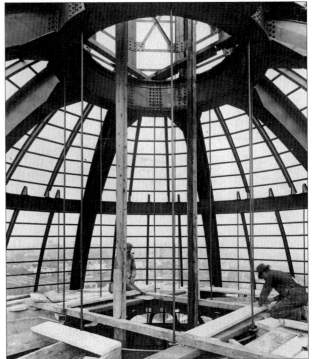

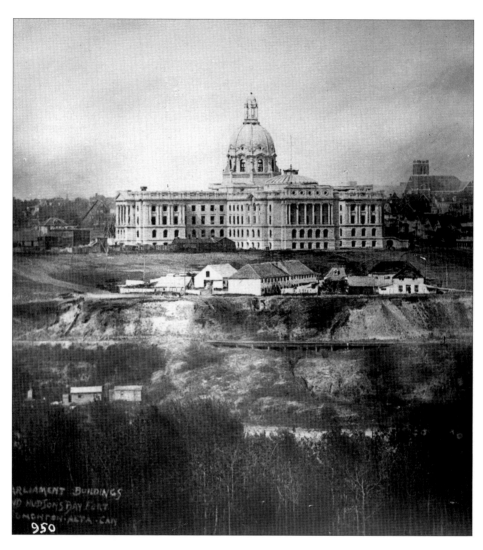

Opposite bottom: *Work began on Alberta's Legislative Building in 1907. Problems with quicksand delayed construction until steel-reinforced concrete pilings were sunk. The building was designed in the shape of a cross, and the cornerstone was laid in 1909. Under it, a Bible and community newspapers were placed.*

Much of the construction material consisted of sandstone quarried near Cochrane. 1911 saw work commence on the dome.

Top: *The Legislative Building was built on the site of the HBC chief factor's Big House, located on a rise overlooking old Fort Edmonton.*

Although incomplete, the edifice hosted its first legislative session in 1911. The building was officially opened the next year by Governor General Arthur Connaught. Despite local protest, old Fort Edmonton was dismantled in 1915. Landscape plans called for a bowling green in place of the fort.

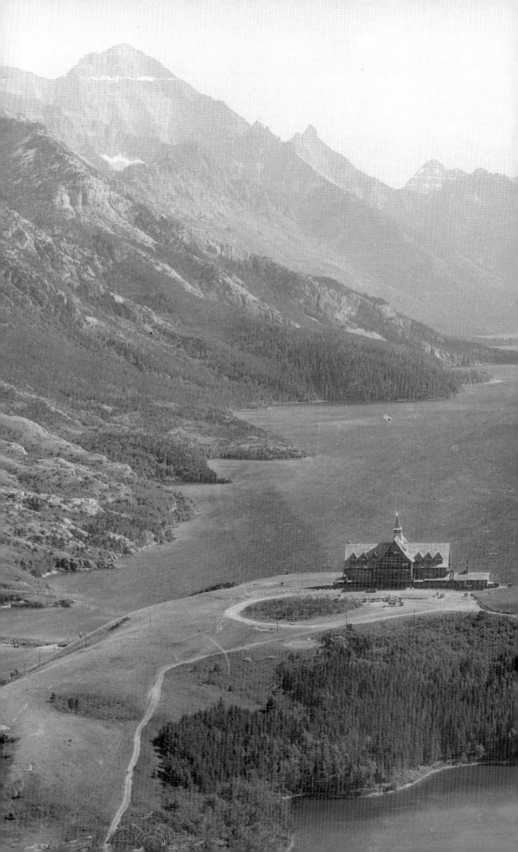

Some oil had been discovered in the vicinity, but Oil City [Waterton] did not yield profitable reserves. Instead, park development became the future, and the arrival of wealthy tourists precipitated the construction of the Prince of Wales Hotel. Waterton and Kootenay Lakes Park, a land where mountains meet the prairie, was inaugurated in 1895. National park status was granted in 1911.

Top: *In 1914, Mrs. R. Lett and A. Driscoll pointed out the splendors at Blue Angel Glacier on Mount Edith Cavell. Their guest was author Sir Arthur Conan Doyle of Sherlock Holmes fame. In 1907, Medicine Hat had impressed another famous author, Rudyard Kipling. Three years later, when locals proposed changing the town's name, Kipling wrote a letter of protest. Other early visitors inspired by the Alberta landscape included artists Paul Kane, Charles Russell, and Carl Rungius.*

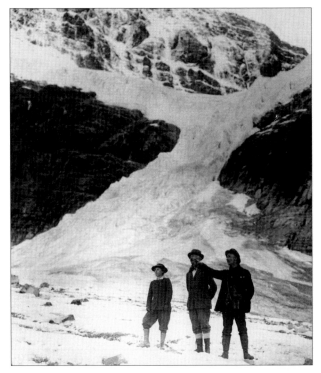

Bottom: *The Seventh International Dry Farming Congress at Lethbridge in 1912 was the occasion for a photograph of Japanese immigrants Yoichi "Harry" Hironaka (left) and James Shimbashi (right). Mr. Hironaka cooked at a Lethbridge hotel and owned a restaurant in Raymond, where many Japanese were sugar beet workers for the Knight [Rogers] Sugar Company. Mr. Shimbashi became the cook at the Prince of Wales' EP Ranch, but later purchased Hironaka's restaurant.*

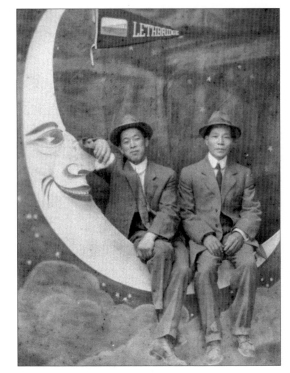

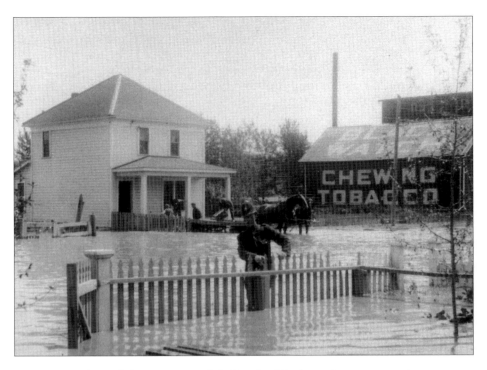

Top: *Geography and climate have granted Alberta mighty rivers and heavy winter snows. Generally, spring temperatures rise slowly, and the snow pack melts equally slowly. However, sudden and unseasonable warm spells, combined with spring rains, can accelerate melting, and significant floods have occurred as frequently as every 10 to 20 years.*

For Edmonton, one of the worst was 1915 (above). Spring run-off was heavy. The waters of the North Saskatchewan River rose and continued rising to 14 metres [45 feet 2 inches]. Onlookers expected the Low Level Bridge to be swept away, until two trains loaded with gravel were driven onto the spans.

The flood claimed one infant and left 2000 people homeless. A brickyard, tannery, factory, two mills, and 50 homes were destroyed or ravaged by the flood. Damage was estimated to be $750,000, at a time when skilled labourers made $2.50 to $3.50 per day.

Southern communities also have a long history of floods. In 1884, Calgary reported that its first flood washed away the bridge on the Elbow River. In 1897, southern Al- berta experienced a once-in-a-century flood. A heavy mountain snowpack and 10 days of rain in June caused the Bow River to rise 5.3 metres [17.52 feet] above normal levels. With both it and the Elbow River overflowing their banks, Calgary suffered extensive damage from the floodwaters and from floating logs, debris, and layers of mud left in their wake.

1902 brought another flood. Again, the Bow could not be held back. The flooding of the Oldman River also created havoc at Lethbridge. Other serious floods hit the province in 1929, 1932, and the 1940s.

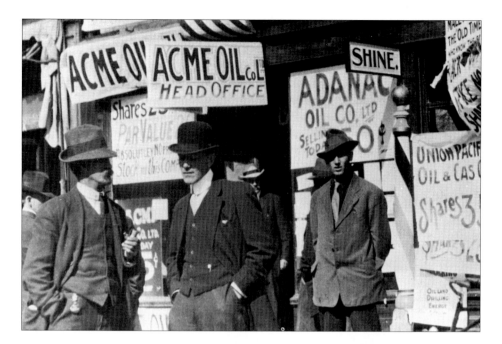

Top: *At Turner Valley on May 14, 1914, drillers struck oil. Within a week of the discovery, 40 oil companies opened their doors in Calgary. Stock speculation was rampant, and some shares jumped from $12.50 to $200 each. Edmonton's economy was also bolstered when 100 oil brokers opened offices. Oil was considered black gold. But the natural gas field discovered at Viking in 1914 meant that the gas production and pipeline industries were beginning equally long-term and much less erratic growth.*

Bottom: *As Alberta's first gusher, the Dingman Discovery Well brought oil from 810 metres [2660 feet] below*

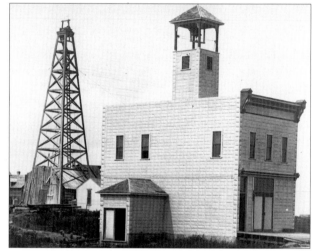

ground to the surface. Holding mineral rights in the area, the CPR helped finance additional drilling by Dingman. In Hell's Half Acre, in the Black Diamond/Turner Valley area, flares burned waste gas all day and all night.

More money changed hands from speculation than from oil production during the next 30 years. But both oil and gas industries were a visible presence, and at Tofield a gas well sat next to city hall.

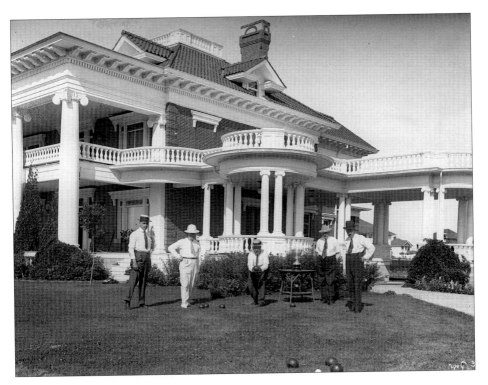

Top: *In contrast to the meagre earnings of many, real estate developers such as William Magrath made fortunes during the settlement boom. In 1912 he built his 14 room mansion in Edmonton's Highlands for $85,000. During the Depression, Magrath would lose his property, but the home was eventually designated a historic site.*

Bottom: *In 1912, an Eaton's six-room, two-story house cost $1000. This elegant Norland model was purchased by the Daniels family from a USA catalogue. Their Lethbridge farm home was often photographed for promotional purposes. Prefabricated mail-order homes had been available since 1908. Precut lumber, windows, shingles, doors, mouldings, casements, and tar paper were included. Materials were numbered for assembly.*

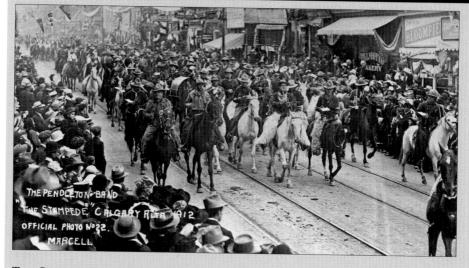

THE PENDLETON BRAND
"THE STAMPEDE" CALGARY ALTA 1912
OFFICIAL PHOTO No 22.
MARCELL

THE CALGARY STAMPEDE, the Greatest Outdoor Show on Earth, was first staged in 1912, but its origins were to be found in the annual fairs already enriching community life. Calgary's 1908 Dominion Exhibition had received accolades as the greatest exhibition in the West. With a total of $100,000 in financing from all levels of government, the organizers had built a general exhibits building, a grandstand, and a livestock building, in Victoria Park. The parade extravaganza featured floats, bands, carriages of dignitaries, and native people in traditional dress. Special excursion trains brought people from as far away as Winnipeg and Spokane.

One of the visitors was Guy Weadick, an American cowboy and trick roper who had toured with the Buffalo Bill Show and the Wild West Show. Almost immediately, he saw Calgary's potential for hosting an annual frontier day celebration that would include world championship rodeo events. Four years later, when he returned, the community had grown to 50,000 people, but it still had strong, living ties to its ranch and cowboy history.

Weadick approached the ranchers known as the Big Four. Pat Burns, A. E. Cross, George Lane, and Archie McLean liked the idea of a reunion for Alberta's pioneer cowboys and ranchers. Each put up $25,000 to stage a celebration of the old days, the daring exploits of cowboys, and the fine livestock roaming the range. John McDougal sought participation of the native people, and old timers such as early whisky trader Fred Kanouse were invited.

In the bronc riding competition of the first Calgary Stampede, Blood cowboy Tom Three Persons from Manyberries walked away as winner. Alberta's Clem Gardner was named All Around Canadian Cowboy, but professionals from Mexi-

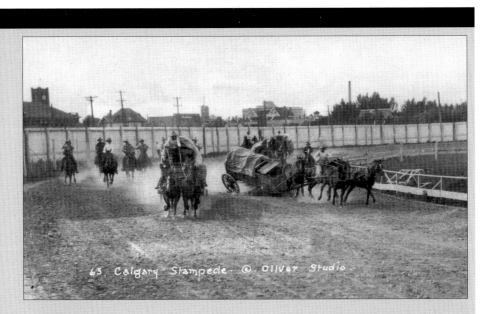

63. Calgary Stampede. © Oliver Studio.

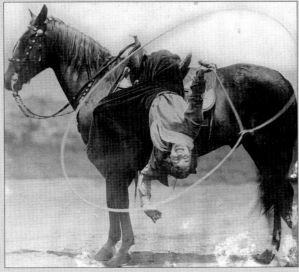

evening was $15 to be divided amongst the outfit's driver and outriders. Bill Somners from Mosquito Creek handled the reins for the outfit declared champion after five nights of racing. Then in his seventies, he was a former stagecoach driver.

Flores La Due knew how to impress the crowd at the first Stampede. As World Champion Fancy Trick Roper, she was without equal. As well as fancy roping contestants, women were also competitors in fancy riding, relay races, bucking events, and trick riding.

co and the USA claimed all other titles.

However, the 100,000 admission tickets sold attested to the Stampede's success. People had travelled from as far as Winnipeg, taking advantage of a half-price excursion fare offered by the CPR.

Calgary first held its famous chuckwagon races during the 1923 Stampede. The purse for placing first each

ALBERTA'S most renowned farmer and inventor was Charles Noble. At one point, his southern Alberta farm was the largest dry land farm in the British Empire. However, it was long days of hard work and a scientific approach to farming that brought him national and international honors.

Born in Iowa, Noble began farming in the Claresholm area in 1903. Needing ready cash, he became a real estate agent for the CPR, which was marketing the enormous tracts acquired as a concession for building railroads.

Inspired by the phenomenal potential of the land, Noble moved his family to a farm at Nobleford, a new townsite named after him by the CPR as acknowledgement for his work. There, Noble became World Flax King by producing 60,000 bushels in 1912, World Oats King with 256,000 bushels in 1915, and World Wheat King with 54 bushels per acre in 1916. All crops were grown without fertilizer by a man who be- lieved that each soil had a specific crop potential. To him, learning how to develop its potential was important life work.

In the Dirty Thirties, Noble tackled the challenge posed by soil drifting. Russian thistle and other weeds flourished during the drought. Traditionally, summer fallow controlled weeds, but it unfortunately also contributed to soil drifting.

Farmer and inventor Charles Noble created an Alberta solution. He designed and marketed the Noble Blade. It undercut weeds and stubble but left the surface "trash cover" intact, therby inhibiting wind-trig- gered topsoil erosion. Noble's district became the first in Western Canada to abandon traditional plowing methods, and consequently escaped most of the soil drifting plaguing other farm communities. His invention was to revolutionize dry land farming, and by 1940 Noble Cultivators Ltd. was manufacturing for an international market.

Eventually, evolving agricultural economics would bring change to the Noble farms and businesses. But the man who loved to feel the texture of the soil had put Alberta farm machinery in fields throughout America.

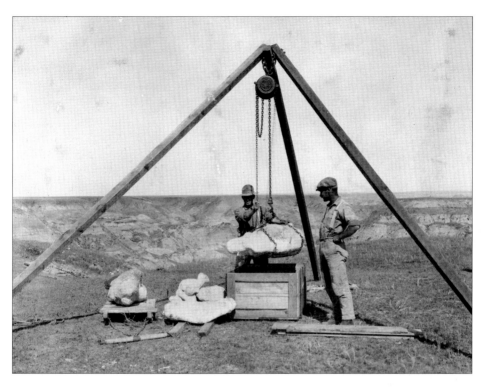

Top: *Old bones were also creating an international reputation for Alberta. Near Drumheller, fossil finds by C.H. Sternberg and his sons included a Corythosaurus and a Chasmasaurus, the latter displaying skin impressions. Once removed, fossil bones were weighed, measured, packed, and hauled to the nearest railway for shipment. Especially abundant was the Albertosaurus, a carnivore weighing about 1.8 tonnes [1.98 tons], measuring 8 metres [26 feet] long, and up to 3.5 metres [11.5 feet] tall.*

Bottom: *Serious research was centered in areas such as the Badlands, but good times were not forgone. Many notable bands and singers were to profit from their Alberta experience and graduate to perform on the international stage. Others, such as this Alderson area family, enjoyed music as folk art and played spoons, pots, and pans as percussion instruments. The broom may have added a unique twang.*

Boom and Bust

Early settler John Walters, who had operated Edmonton's first cable ferry across the North Saskatchewan, watched as the province's population surged. In response, in 1909, he built the paddle wheeler *City of Edmonton*. By 1915, as many as 500 passengers enjoyed each weekend excursion to his summer resort 28.8 kilometres (18 miles) up river.

Clearly, survival was no longer the only concern. Serving recreational and cultural needs had become important. Community services such as public utilities, post-secondary schools, fire departments, hospitals, and local police were needed. Legislation was also in demand to acknowledge that women, as well as men, had played essential roles in pioneering.

However, the teens and twenties also brought disaster to the province. On June 19, 1914, at the Hillcrest coal mine in the Crowsnest Pass, an explosion killed 189 men. At the time, it was the worst mine explosion in Canada and third worst in the world. Four years earlier and three miles away, about 30 miners were lost in a Bellevue mine explosion, a tragic addition to the over 500 mine-related deaths in the first half of the century.

World developments also had an impact. As hundreds of departing troops marched through the streets, none knew who would return as heroes and who would not return. There were many heroes, but Alberta airmen became some of the best known. Peace River's Donald MacLaren shot down 48 planes and six balloons. Calgary's Fred McCall was highly decorated. Roy Brown, who shot down the Red Baron, was claimed by both Edmonton and Calgary. Edmonton's other heroes included "Wop" May and "Punch" Dickins, but the city was also home to the first Alberta airman to die in the war.

The war did mean jobs to the home front. Recognized for quality jeans and overalls, Edmonton's Great Western Garment Company had been established in 1911, and it operated with unionized labour. War contracts of 3000 shirts for the Canadian government and 20,000 pants for the British army had the GWG factory running at full capacity. The 150 employees, mostly female, worked 10 hour weekdays plus a half day on Saturday. Not until 1917 did the Factories Act legislate the eight hour workday.

Most people still toiled on farms. In addition to farm owners, according to a 1921 Alberta Agriculture survey, 14,720 unpaid farmers' sons worked the land. Subsequent surveys counted all unpaid workers, and in the midst of the Depression, that number rose to over 32,000. During the Second World War, the number dropped to about 21,000, a sign that Alberta demographics were changing.

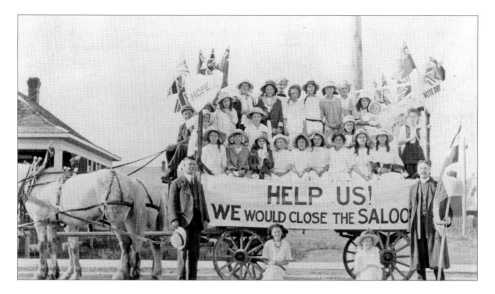

Top: *The Woman's Christian Temperance Union was a formidable foe, intent on closing the saloons and eradicating the evils of alcohol. The first WCTU in Alberta was formed during 1904, while Alberta was still part of the Northwest Territories. Already active in the cause, Louise McKinney—who would serve as provincial president for 28 years and would be elected world vice president for the WCTU—had moved to Claresholm in 1903. In the same year, national executive member Mrs. S. J. Craig became a resident of Olds. By 1912, the two had been instrumental in organizing 43 locals of the WCTU. Two years later, by the time of the provincial convention in Wetaskiwin, individual membership had reached 987, and momentum continued to increase. Prohibition supporters included many women's clubs, religious leaders, and the United Farmers of Alberta. Their pressure against the "liquor traffic" resulted in a referendum.*

For the July 1915 Prohibition march in Edmonton, about 11,000 people formed a parade that stretched for more than two miles. This Calgary float from the Presbyterian Sunday School implied that a dry vote was a vote for children. In the referendum, victory went to the Prohibition forces. The vote was 4500 for legal liquor sales, but the 7900 who voted for a dry province won the plebiscite.

Women couldn't vote in the referendum, but they had proven to be an indomitable lobby group. In fact, their efforts had a two-fold objective. They wanted prohibition, and they wanted the franchise to press for other legislation, especially that which would improve the lives of women and children. One of the many capable leaders during the suffrage campaign was Fort Macleod's Henrietta Muir Edwards. Chairing the National Council of Women's standing committee on laws, and serving as its vice president for Alberta and Saskatchewan, she and other suffragists petitioned and lobbied until women could no longer be denied the provincial or federal vote. Recognized as an expert on the legal status of women in Alberta and Canada, Muir Edwards was often consulted regarding pertinent legislation.

R. B. Bennett

IN JANUARY 1897, Richard Bedford Bennett (centre left) moved to Alberta when James Lougheed offered a partnership in his Calgary law firm. Following the real-estate boom of the 1880s, the wealthy, thirty-five-year-old Lougheed had been appointed to the Canadian Senate. Ten years later, with less time for his law practice, Lougheed welcomed Bennett into his circle of business, legal, and political friends. The unmarried Bennett made his home in the Palliser Hotel, and to his new friends, he became R. B. Soon, he took over as legal representative for the Hudson's Bay Company and for the CPR in Alberta. He also joined business moguls like Lougheed and Pat Burns in many investments.

Bennett became a shareholder or director in industrial, real estate, oil, and utility companies such as Calgary Power and Canada Cement. In 1912, he was instrumental in the amalgamation of the Alberta Pacific Grain Elevators, another investment contributing to his enormous wealth.

The well-known Bennett won an 1898 election as Alberta representative to the Territorial government in Regina. Here his oratorical skills earned him the nickname Bonfire Bennett. Later, he became the leader of the provincial Conservatives but lost in the first provincial election. In 1910, he was elected to the legislature, where his speeches about British ideals and the Empire often made him seem more British than new immigrants from England.

Making the move to federal politics in 1911, Bennett won 61 percent of the vote in his Calgary riding. Eventually becoming leader of the federal Conservatives, he was elected in 1930 as the first of two prime ministers from Alberta. The victory meant that he faced the challenge of leading Canada through the Depression.

Bennett did gain preferential tariffs from Britain. However, his initiative to establish relief camps for single men, though well-intentioned, was less popular. By 1935, he was advocating a New Deal, which included progressive taxation as well as unemployment and health insurance. Still, a disillusioned country defeated his party.

Himself disillusioned, Bennett moved in 1938 to England, where he was made a Viscount in the British House of Lords. With that, he achieved goals established early in life. He had become wealthy; he had been prime minister; and he now held a peerage.

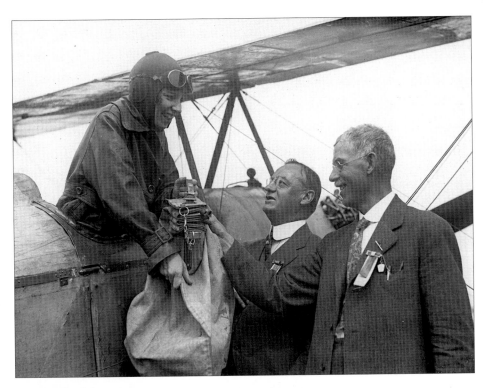

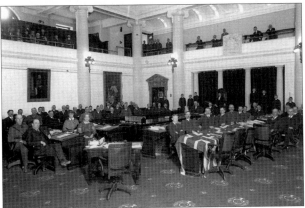

ing to Claresholm in 1903, she was eventually elected as a member of the Non-Partisan League, one of the first Alberta protest parties.

Top: On July 10, 1918, American Katherine Stinson flew a pouch containing 259 letters from Calgary to Edmonton. Received by the Edmonton Exhibition manager (centre) and the postmaster (right), the pouch became the first airmail delivery in Canada. Two years earlier, in exhibition flights, Stinson had introduced the Martin biplane to Albertans.

Bottom: Roberta MacAdams, the woman seated to the far right, and Louise McKinney, next to her, were elected to the Alberta Legislature in June 1917. They were the first elected female legislators in the British Empire.

Nursing Sister MacAdams was the soldiers' representative at a time when active service for women was limited to the nursing corps. Born in Ontario, McKinney had wished to become a doctor, but instead became a teacher. Mov-

CANADA'S most famous suffragist, Nellie Mc-Clung (back, left), arrived in Edmonton in 1915. A rousing success in the Votes for Women movement in Winnipeg, Nellie seemed destined to become Manitoba's first female legislator, until the family followed her husband's career to Alberta.

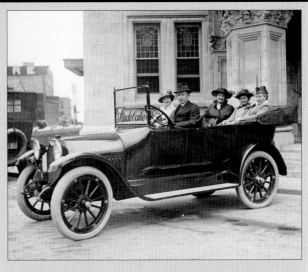

She immediately joined forces with the local Women's Christian Temperance Union and others in the fight for prohibition. In the effort to ban Demon Rum, she led some of the longest parades staged in early Alberta. An outstanding public speaker, she was instrumental in garnering a "yes" vote in the prohibition referendum.

The role of women in that victory, as well as their pioneering efforts and war-related work, became the rallying cries for women's suffrage. McClung directed her phenomenal skills as a women's leader, political organizer, and popular orator towards gaining the franchise. Despite some restrictions, Alberta women became eligible to cast ballots in 1916.

Months later, Edmonton hosted Britain's most famous suffragette, Emmeline Pankhurst (back seat, centre), who applauded the win. Her objective on that occasion was a speaking tour to raise money for the war effort, but in 1919 Pankhurst returned to Alberta as a lecturer on women's hygiene.

McClung's star was still on the rise. In 1921 she was elected as a Liberal in the Alberta Legislature, making her amongst the province's first four female legislators. She served five years for her Edmonton constituency, lobbying for such causes as improved property rights for women, public health nurses, public education, and less rigid laws regarding birth control and divorce. Moving from Edmonton to Calgary in the same year as the 1926 election, and at a time when support for prohibition had waned, McClung was not re-elected. She returned to her earlier career as a writer and public speaker. Six years later, she moved to Victoria, but continued serving Albertans and all Canadians on the CBC board of directors, and as a Canadian delegate to the League of Nations.

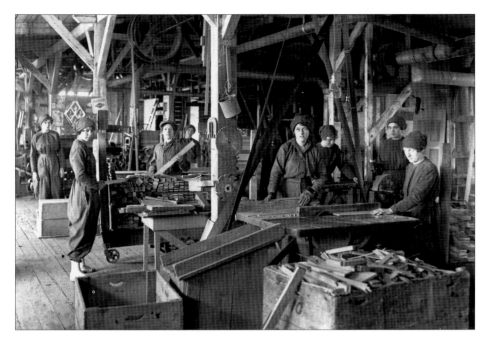

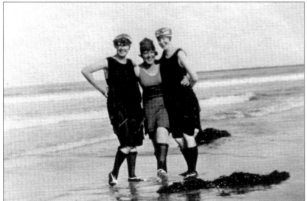

Bottom: Increasingly liberal attitudes were reflected in women's fashion. During the 1890s, those few females who dared to swim were completely covered by their bathing costume. Pantalettes had ruffled skirts, and tunics sported collars and ties. Ten years later, feminine swimwear still featured shoes, full stockings, and collared tunic, but sleeves were shorter, and the A-line skirt over the pantaloons was detachable. By the twenties, respectable Alberta bathing beauties revealed arms and shoulders and flashed alluring knees.

Top: From the earliest days, Alberta women have entered a variety of careers. Many farm women had the primary role in poultry and dairy work, and some helped in the fields. Other women found employment as teachers, nurses, cooks, waitresses, seamstresses, and domestics. Some pursued the arts or became telephone operators and clerks. With the war, higher paying, non-traditional occupations also opened to them and brought increasing financial freedom. These women were employed at an Edmonton lumber yard.

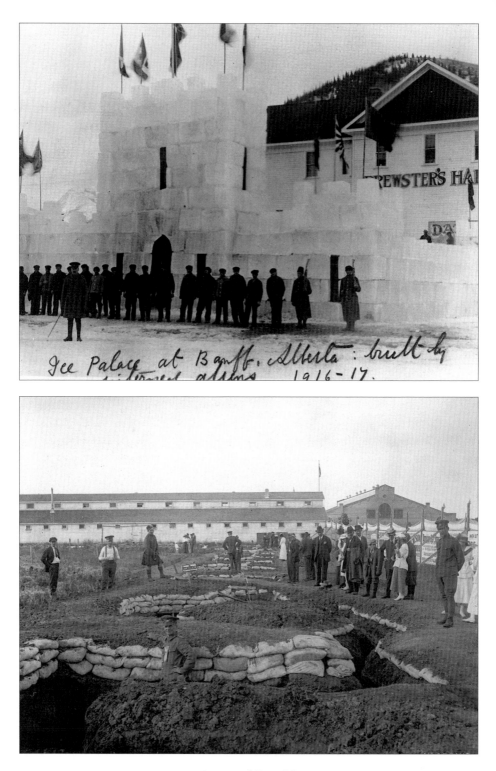

Ice Palace at Banff, Alberta: built by interned aliens 1916-17.

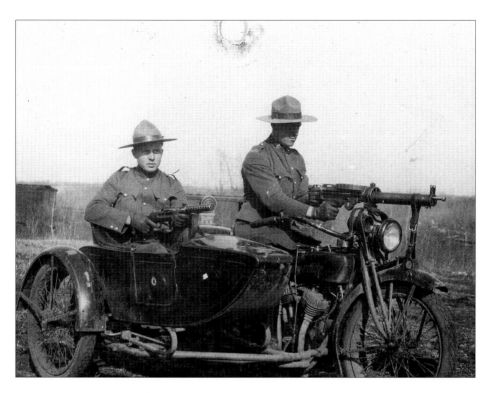

Opposite top: *During the First World War, many immigrant Ukrainians, Germans, and Austrians without Canadian citizenship were sent to camps at Castle Mountain, Munson, and Miette Valley near Jasper. Labelled internal aliens, these civilian internees built this Banff ice palace and the local golf course. They made improvements to the Cave and Basin, and they built park roads. Thousands of Alberta families had roots in enemy countries. Even those who supported the war effort, who were naturalized citizens, and whose children enlisted, often experienced prejudice.*

Opposite bottom: *During the war, trenches were dug in Edmonton, but the purpose was simply to illustrate conditions of trench warfare. Although genuinely concerned, those on the home front knew little of the muddy and unsanitary conditions that many Alberta recruits would endure. In 1916, Lethbridge had 20 percent of its population enlist, a record for Canadian cities.*

Top: *The newly established Alberta Provincial Police Force began its campaign against crime in 1915. It waged a war on illegal liquor, especially in the Crowsnest Pass, where successful bootlegger and rum runner Emilio Picariello had a strong following. The APP also played a role in maintaining order during labour disputes. In the twenties, this gun-mounting motorcycle was utilized for such duties.*

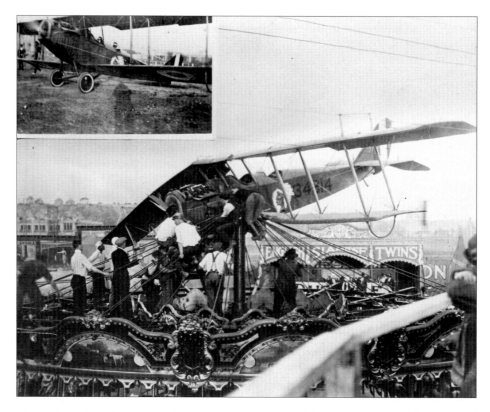

Top: *Throughout the teens, Calgary Exhibition and Stampede crowds thrilled to the aerobatics of biplanes. On July 5, 1919, Captain Fred McCall took two passengers on an aerial tour of Victoria Park in Calgary. When the motor stalled, the skilled First World War pilot, who had downed 37 enemy planes, avoided catastrophe before Stampede spectators. He crash-landed on the merry-go-round, and no one was hurt.*

Bottom: *Who would have guessed that this was a pro-motional event for the Cal-gary Stampede? This 1921 ski jumping structure was constructed on the grandstand roof. Ten thousand attended the championships. They were scheduled to be staged again in 1922, but chinook temper-atures and winds cancelled the event.*

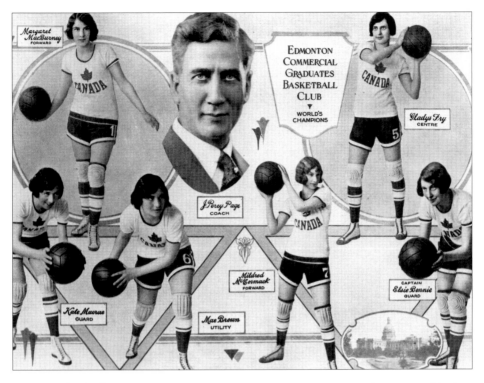

Edmonton Commercial Graduates Basketball Club — World's Champions

Margaret MacBurney — Forward
Gladys Fry — Centre
J. Percy Page — Coach
Mildred McCormack — Forward
Kate Macrae — Guard
Mae Brown — Utility
Captain Elsie Bennie — Guard

Bottom: *Sports Hall of Fame star Lester "Slim" Haynes was probably Alberta's best pitcher. His career peaked between 1915 and 1926. Pitching for the Stavely Ball Club, he had three shutouts in one day. At the time, baseball was popular in the province, and bets among farmers on one of Haynes' games could total $50,000.*

Top: *The inventor of basketball called the Edmonton Grads the "finest team that ever stepped on a floor." Comprised of graduates from McDougall Commercial High School, the club won 93 percent of its games between 1915 and 1940. During that 25 years, only 48 players were officially listed. Coached by Percy Page, the Grads held 108 titles from local to world levels when they retired. In three European tours, the team won all of the games that it played.*

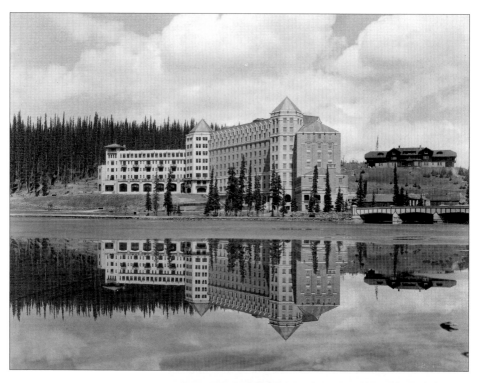

Top: *A Stoney native first led Tom Wilson to the Lake of Little Fish, eventually renamed Lake Louise. Situating its construction camp of Laggan in the area, the CPR soon realized the potential of the beautiful location. First, it built a log chalet for mountaineers. Tourists followed. The chalet expanded to a chateau, and in 1912 an annex was added. After a 1924 fire, the chateau was rebuilt and assumed much of its present-day appearance.*

Bottom: *Early Alberta film maker and photographer Bill Oliver received international*

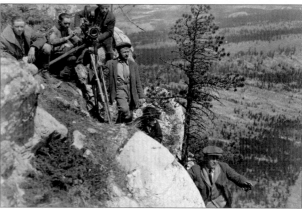

recognition for his work at a time when the province was first becoming a paradise for movie makers. Here a Hollywood film, Valley of the Silent Men, *is being shot at Banff in the twenties. Mountain guide Edward Feuz (sec-*

ond right of camera) assisted with this scene on Tunnel Mountain. The movie Back to God's Country, *filmed at Calgary in 1919, earned a 300 percent profit for producer E. Shipman and its backers.*

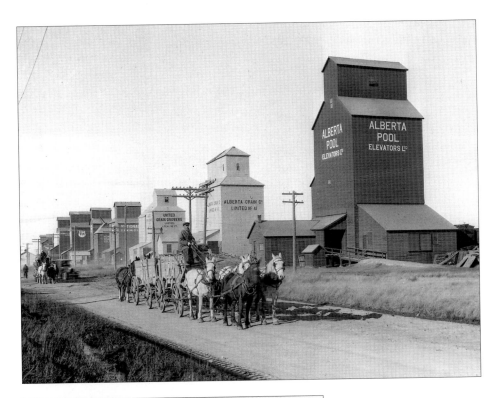

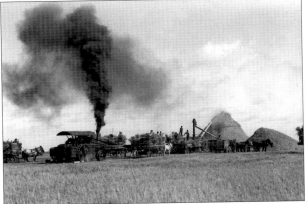

Top: *Elevators were not only places to store grain but also symbols of growth and success. Built every six miles along prairie track, seven or more such structures might stand side by side. Early companies included Northwest, Alberta Farmers Co-op, Alberta Grain, Reliance, Federal, Ellison, and Midland. Many amalgamated under the names Alberta Wheat Pool (1923), United Grain Growers (1906), Parrish and Heimbecker (1909), and Pioneer (1913).*

Bottom: *Since Alberta's weather was never predictable, the largest-scale threshing and other harvesting operations possible were mounted when crops were ready. On one farm at Dalroy in 1915, each of five tractors hauled five binders, and each binder cut a 12 metre [40 foot] swath. By the 1920s, one farmer might be using a steam tractor while his neighbour used the latest technological wonder, the gas tractor.*

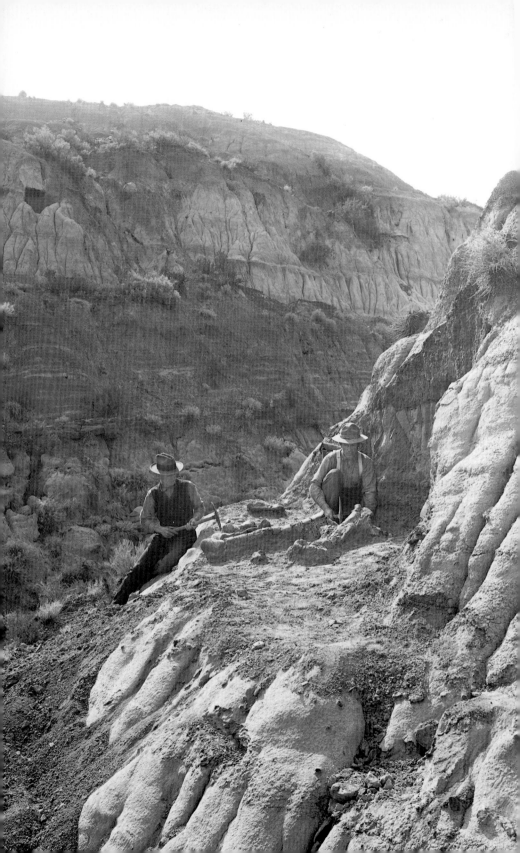

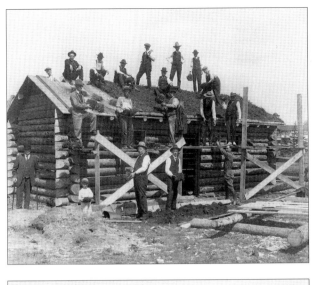

THE COURT HOUSE EDMONTON, ALBERTA.

in. Wearing a Stetson and standing on the scaffolding is Colonel James Walker, one of Alberta's first Mounties. Already, Alberta museums, galleries, and private collections were dedicated to similar goals. In 1903, Banff Park Museum had opened. From its inception, the University of Alberta established research collections. By 1924, an Edmonton art gallery welcomed visitors. Ten years later, the Ukrainian Museum of Canada became an Edmonton attraction.

Bottom: A continuing challenge has been balancing the effects of population growth and technology with the preservation of wildlife habitat and corridors. Given the fiercely independent and entrepreneurial spirit of Albertans, the Edmonton Court House, built in 1912, was to hear some of the arguments relating to these issues, but it was a Leduc photographer who managed to capture the dilemma visually.

Opposite: By the 1920s, international palaeontologists and museums had become increasingly interested in the province's treasures. Bones in the Belly River Formation had attracted the attention of turn-of-the-century surveyors. In the teens, the Drumheller Valley was the site of many excavations, and the work there had continued.

This 1922 expedition proved very successful for Sternberg (right) and Abbot (left), who excavated these fossils for Chicago's Field Museum of Natural History.

Top: The 1925 Old Timers Association was determined to preserve the province's pioneer heritage, and their goal was to build an authentic log cab-

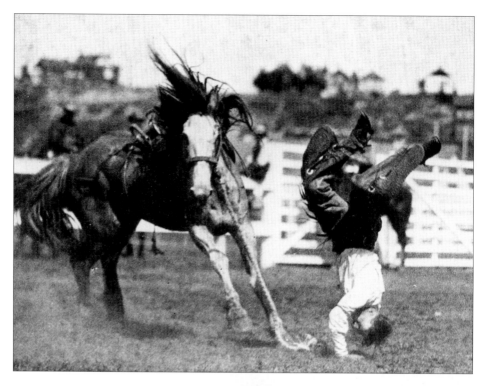

Top: *There were many out-laws amongst his kind, but Cyclone was one of the worst. In 1925 he was still landing cowboys on their heads. Called a bucking beast and black demon, he was first ridden by Tom Three Persons. With that ride, Three Persons became Saddle Bronc Champion in the 1912 Calgary Stampede. He won a saddle, a belt, and $1000. But Cyclone had been only temporarily subdued.*

Bottom: *The Prince of Wales (right), later crowned King Edward VIII, visited Alberta on many occasions.*

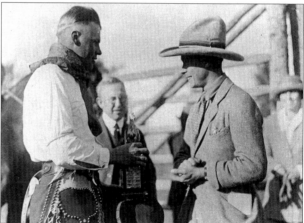

His E. P. Ranch was located near Pekisko. Appreciating cowboy skills and tradition, he sponsored a Prince of Wales Trophy for the Canadian Champion Bronc Rider. Here he presents the trophy to 1925 winner Pete Van Dermeer. In the 1940s, Wallis Simpson, wife of the abdicated Duke of Windsor, also holidayed at the Pekisko ranch.

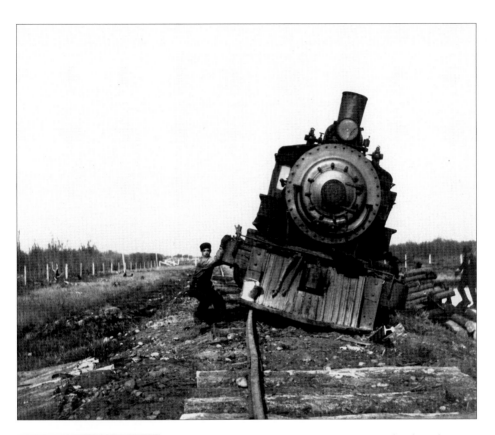

Bottom: *Building irrigation dams, canals, and ditches was demanding work, but without managed water supplies, many areas could not have supported prolonged farming. These employees of Lethbridge Northern were photographed in a wooden siphon used in the construction of canals during the 1920s. Following the Lethbridge lead, Taber had established an irrigation district by 1917. During the twenties, still others followed, including Mountain View, Magrath, and Raymond.*

Top: *In isolated northern areas, an accident like this 1925 derailment near McLennan posed serious problems for the Edmonton, Dunvegan, and British Columbia Railway. Completed in 1915, it was intended to open the Peace River district to homesteaders, and was instrumental in the growth of towns such as Westlock, Slave Lake, High Prairie, Kinuso, and McLennan.*

IN 1929, Edmonton's Emily Murphy won Canadian women full rights as persons. Spearheading a petition to the Privy Council in London, she enlisted the help of four other Alberta women: Nellie McClung, Louise McKinney, Henrietta Muir Edwards, and Irene Parlby. Already considered powerhouses in provincial politics and legal and social reform, they became known as Alberta's Famous Five. Their petition challenged contemporary interpretations of the BNA Act, whose use of masculine pronouns made women ineligible for appointment to the Senate. Having won the provincial and federal vote, many women saw this exclusion as one of their last legal obstacles. Fearless Murphy had the perseverance, knowledge, and connections to tackle the issue.

She had arrived in Edmonton in 1907 when her husband, an Ontario-born Anglican with an international reputation as an evangelist, decided to buy an Alberta coal mine. Emily

brought with her a reputation of her own. Writing under the pseudonym Janey Canuck, she had entertained Canadian and British readers with her travelogues. Becoming a converted Albertan, Murphy increasingly focused on Edmonton and western development as the subjects for her ever-popular books, but much more than writing occupied her time. She served on the executives of dozens of women's clubs, gravitating towards those clubs whose goals addressed social

and legal reform. Because of her work, Murphy was appointed magistrate for Edmonton. Her authority was quickly extended to the rest of the province. That appointment made her the first female magistrate in the British Empire.

Among other accomplishments, Murphy was the first woman on the hospital board in Edmonton. She initiated a local Victorian Order of Nurses, and public playgrounds. *The Black Candle,* her book on drug abuse, was intended for a general audience and was also a first. All previous treatment of the subject in North America had been for use by medical, legal, or other specialized professionals.

Despite social reform work that impacted all Canadians, Murphy was known for her sense of humour, and she loved to dress in costumes. For a 1928 press club dinner, Murphy appeared as this princess. On another occasion, she donned the costume of an Amazon.

development occurred between the teens and the thirties. This Chinese cast brought the atmosphere of the Far East to Edmonton's Moose Hall in 1931; but as early as 1904, full-scale productions such as Chimes of Normandy were staged in the capital. In 1913 the Pantages Vaudeville Theatre had opened in Edmonton. Seating more than 1600 people, the theatre charged 25–50 cents for an evening performance. Chautauquo, a performing troupe whose goal was to challenge audiences to greater moral commitment, had begun touring Alberta in 1916.

Bottom: *Many First World War pilots returned to Alberta and became barnstormers, charging passengers about $15 to fly for five minutes in a biplane. After his barnstorming days, "Wop" May (standing centre) joined other bush pilots serving*

northern communities. This 1929 flight was one of the first carrying air mail for Fort McMurray. Passenger and air ambulance flights were even more important to remote areas.

Top: *Significant cultural*

Alternatives and Armies

The twenties brought widespread optimism. Dismay and apprehension filled the thirties. But unlike people in other regions, Albertans spawned new political movements when economic concerns became a priority. To them, entrenched traditional parties possessed entrenched problems.

The United Farmers of Alberta had been one of the first home-grown alternatives. With the deteriorating economic circumstances of the Depression, demand for an alternative once again swept the province. The unusual economic theories of Englishman C. H. Douglas, combined with radio technology and personal charisma, gave William Aberhart his edge with the voting public. As a religious and educational leader, he had the ability and connections needed for the successful organization of his Social Credit Party.

However, it may have been an evolving Alberta personality which brought him the landslide victory of 1935. As diverse as they were, Albertans seemed to unite in preferring to place their faith in new faces and new ideas regarding government. Eventually, however, after years of re-election, even this party would be viewed as unresponsive to the people, a fatal flaw. Years later, another new party would garner grassroots support, and the protest vote would became a hallmark of Alberta politics.

Through the thirties and forties, other aspects of a unique Alberta identity appeared. In the province, striking a balance between the concerns of labour and the priorities of the entrepreneur was difficult. In 1931, Calgary witnessed a protest march of 2000 labour supporters. On December 22, 1932, Christmas trees were being sold in Edmonton's market square while over a thousand protesters staged a hunger march. The day ended with violent confrontations and many arrests.

By the 1940s, Albertans were embroiled in another world war, and again, the province was the site of flight training and prisoner of war camps. Oil and gas discoveries also made history, changing the very fabric of the province. Farms grew larger, but often work on the rigs, petroleum royalties, and payments for pipeline right-of-ways helped finance the farms. Businesses, public utilities, transportation services, increased tourism, and a vast array of public services began to drive an economy once based primarily on agriculture and forestry. The old ways and old values continued to be evident, especially in ideas of land management and conservation, but the horizon was acquiring a new look.

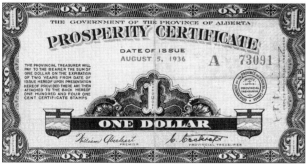

Bottom: *During the Depression, Social Credit promised each Albertan $25 per month. In 1936, a bankrupt Alberta became the first province to default on a bond. Civil servants' cheques were not honored at banks, so the government introduced a new monetary system. Dubbed*

"funny money," certificates were issued immediately. By 1938, Canada's Supreme Court ruled that this was an attempt to create currency. Only the federal government could print money, and the scheme was outlawed.

Top: *A long-standing battle between Alberta and Ottawa ended in the early thirties when the province won control over its natural resources. Prime Minister Mackenzie King (high-backed chair) and UFA Premier Brownlee (seated next right) signed an agreement allowing provincial coffers the revenue from oil and gas royalties. Beginning in 1976, the Heritage Trust Fund received 30 percent of these revenues to support and diversify the economy.*

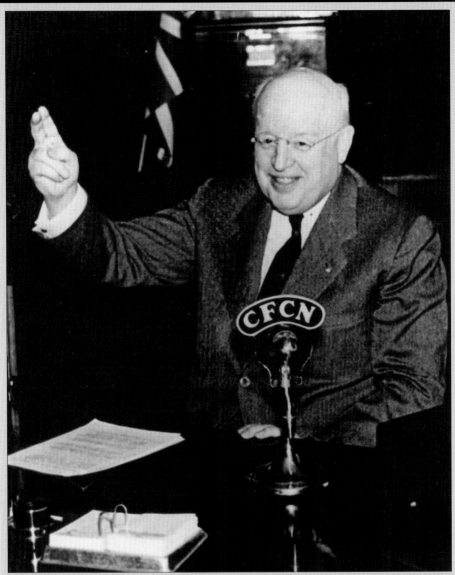

BIBLE BILL Aberhart, principal at Crescent Heights High School in Calgary, was also the voice of the Prophetic Bible Institute on CFCN radio. Understanding the power of radio and public education, he convinced voters to give his newly-founded protest party, Social Credit, a landslide victory in the 1935 provincial election. The ruling UFA party did not elect one member. Social Credit remained in office for 36 years, until the landslide victory of the Lougheed Conservatives.

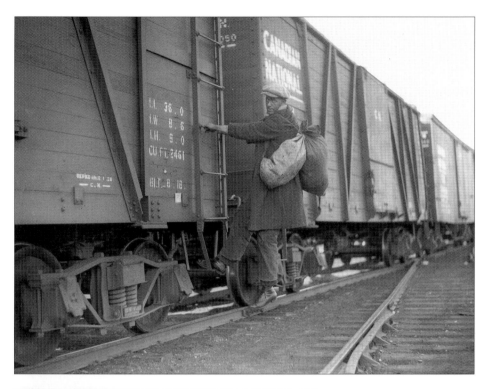

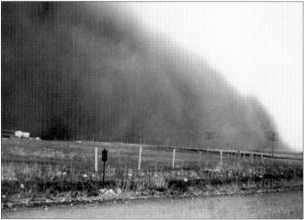

Top: *From 1931–1937, about 21,000 people moved away from the province. Young, single men were especially likely to ride the rails or join the On to Ottawa Trek. Alberta labour had strong support from unions, as well as purportedly having Communist leadership. In Edmonton and Calgary, relief workers and the unemployed staged parades and hunger marches, which sometimes became violent.*

Bottom: *This Okotoks dust storm in July 1933 was only one of a multitude, especially in the Palliser Triangle, which was the hardest hit area of the province. When a storm rolled in, midday could seem like night. In southern Alberta, even the CPR had to cope with the dust disaster. The railway used snowplows to clear the tracks of ten-foot drifts.*

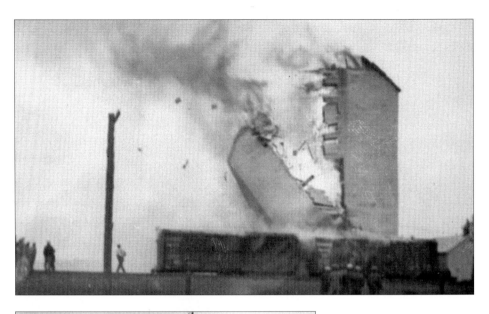

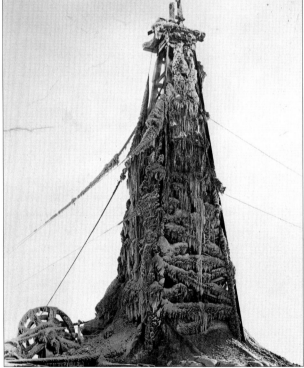

southern Alberta, heavy snows with hurricane-like winds created snowdrifts up to 15.2 metres [50 feet] high in gullies. Livestock caught in the storms died. Even the oil industry did not escape unscathed. In 1936, the Emerald well at Wainwright blew out of control. Once capped, it crusted with ice.

Top: *A 1937 fire at the Coaldale grain elevator seemed a visual symbol of the disaster affecting prairie grain farmers. In 1927, wheat had sold for 98 cents a bushel. In 1939 a bushel brought 58 cents. At the same time, because of the drought and soil drifting, production declined, but production costs doubled.*

Bottom: *Disaster became a seemingly daily occurrence during the latter 1930s. A heat wave in 1936 destroyed crops and claimed lives. During the winter of 1938, in*

back taxes, a fortunate few acquired additional land by meeting the outstanding tax obligations. These farmers were to become well-off in the good years that eventually returned.

Top: Unrest smouldered and then flared. Returned veterans were particularly bitter. Jobs were scarce and wages were low. A Crowsnest miner received a cheque for 90 cents after having worked only one day in two weeks. To qualify for relief, men were assigned to civic projects or bush camps. Companies objected to relief workers receiving regular wages. Instead, they received 20 cents per day plus the tobacco bonus, a 10 cent pack of cigarettes for a week's labour.

Bottom: Some families did not fare badly during the Dirty Thirties. These Drumheller children took dancing lessons. Although half of the rural population did live in three-room homes, and many farms were lost due to

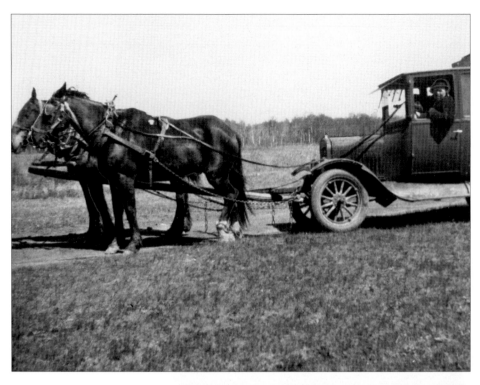

Top: *As the 1930s approached, buggies had been abandoned in favour of the new automobiles. Then, when people could not afford gasoline, horses were hitched to cars and trucks. Labelled "Bennett buggies", they were a populist jibe at the millionaire prime minister from Alberta. Holding office from 1932–1935, R. B. Bennett was considered ineffective in dealing with the Depression, but he was acknowledged as having few peers when it came to long speeches.*

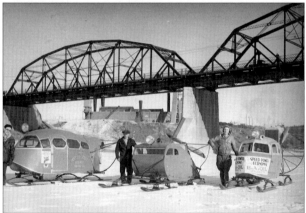

Bottom: *Even during the Depression, many Albertans were still progressive and forward-thinking. No matter what summer brought, winter could be counted on to bring snow. These pioneer snowmobiles were built in Edmonton and used in 1937. In Cold Lake, Bill Clark bought a snowplane. Looking like a Volkswagen on skis, it had a four cylinder motor and a propeller.*

RATS *are coming!*

ALBERTA *the only* **RAT-FREE** *Area in North America*

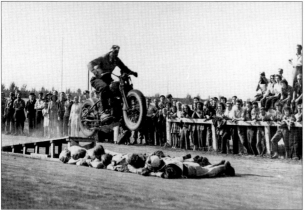

Top: *The bragging was justifiable, and the enforcement vigorous. How long had Alberta been rat-free? Surely forever! So, from the earliest settlement years, every Albertan was expected to report suspected rat signs to Alberta Agriculture. Reminiscent of the propaganda techniques used during both wars, this campaign depended on fear, pride, and determination. The department also sponsored a lending library, general information, and programs on this and many other topics.*

Bottom: *Sports continued to play an important role in the lives of Albertans. At this 1938 motorcycle meet, both competitors and volunteers demonstrated courage. Al-* *ready, motorcycle racing had a 25 year history in the province. Its Black Cup was awarded to the winner of Turner Valley's five mile hill climbing race.*

Top left and right: *In 1932, American and Canadian legislation created the Waterton-Glacier International Peace Park, straddling Alberta and Montana. It attracted sightseers from both sides of the border. Travelling between the two countries, this touring car displayed both Alberta and Montana plates for the 1927 adventure. At times that year, heavy rains transformed roads into quagmires. Travel conditions were to improve with the completion of the Chief Mountain International Highway in 1935.*

Bottom: *The 1936 movie* Rose Marie, *starring Jeanette MacDonald and Nelson Eddie, was filmed over the course of two weeks near Banff townsite, though some scenes were also shot in Quebec. By 1930, only 85 theatres served Alberta communities. Given the Depression, many rural people did not view their first movie until the forties. But the fascination prompted one Alberta woman to name her daughter Jeanette Rosemarie. Years later, the province proved ideal for filming scenes in* Doctor Zhivago, Lonesome Dove, Dances With Wolves, Legends of the Fall, *and many other movies.*

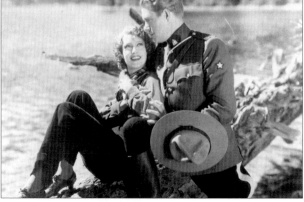

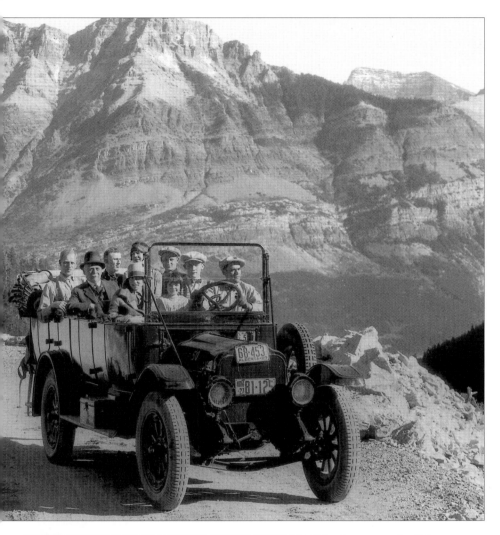

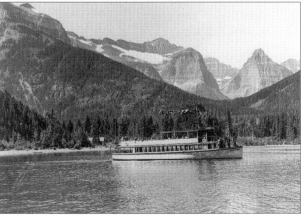

Bottom: *On Waterton Lake in the world's first peace park, tourists could sightsee from the passenger launch, the* International. *It made three scheduled runs per day between Waterton and Ghost Haunt, Montana. In 1928 the trip cost $1.50.*

Top left: *During the Second World War, women were recruited into the Canadian Women's Army Corp [CWAC], Women's Royal Canadian Naval Service [WRCNS], and Women's Division, Royal Canadian Air Force. Female personnel became drivers, file clerks, hospital staff, kitchen workers, and recruitment/training officers. Alberta's Lieutenant Colonel Mary Dover was Canada's highest ranking female officer. Above, Corporal Sadler [Marg Gilkes] serves at Vermilion Agricultural College, a CWAC training base for over 200 women.*

After the war, she became a Calgary policewoman.

Bottom: *Seventeen British Commonwealth Air Training Program bases were opened in Alberta. Boasting space, sunny weather, and security, small towns such as Cold Lake, Nanton, and Claresholm welcomed trainees from Australia, Britain, and New Zealand. Americans also flew out of Edmonton to their Alaska bases. In 1942, these Penhold trainees shopped for Christmas gifts at Osbourne's Ladies Wear in Red Deer.*

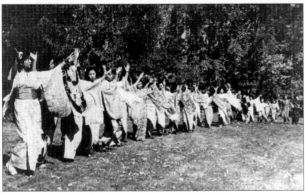

Top right: *The Kananaskis site for Camp Ozada was beautiful, but the tents were reserved for prisoners of war. Other mountain POW camps operated near Banff and Jasper. Civilian internment camps for Canadian immigrants of Japanese, German, and Ukrainian ancestry were, once again, also situated in these locations. Road building throughout the parks depended on the labour of both POWs and civilian internees.*

Bottom: *At home, Canadian-born children of pioneers with German or Japanese heritage again suffered. One who experienced stigmatization was the daughter of 1907 immigrant James Shimbashi. She was refused a student nursing position at the Lethbridge hospital until the exclusion was protested. However, by 1949, people were trying to reconcile that painful heritage. At Picture Butte, where Japanese had settled in the twenties, these women performed the Bonodori as part of a Buddist ceremony.*

Top: *The car under Dinny the Dinosaur at St. George's Island Zoo suggests a fascination with the creature representing the province's earliest history. In 1988, at Devil's Coulee near Milk River, the first dinosaur eggs with intact fossil fetuses were found. 1995 brought another exciting find at Cochrane. The jaw of a new dinosaur species was discovered. The mole-like Aphronorus lived 600 million years ago. But then, Alberta has always been a place to preserve the old and pursue the new.*

Bottom *On the football field, the enemy was Ottawa. It was 1948, and Calgarians were determined to win Alberta's first Grey Cup. Their pre-game celebrations included a square dance in Toronto; and their parade was led by two Sarcee in full regalia with a chuckwagon, riders, and fans bringing up the rear. The Stampeders won a 12 to 7 victory, and one of the heroes was Normie Kwong, the China Clipper. Later, he joined the Edmonton Eskimos, a dynasty bringing 11 Grey Cups to the City of Champions by 1993.*

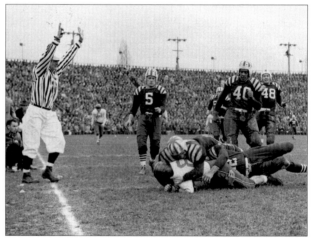

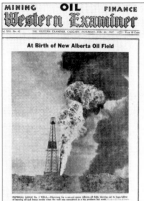

MINING **OIL** FINANCE

Western Examiner

At Birth of New Alberta Oil Field

VI, and her mother had been the first reigning monarchs to visit Edmonton.

Top: *The discovery of the Leduc oil field ushered in a new era for Alberta's oil industry. With 200 million barrels of oil, it was ten times larger than the Turner Valley field. The 1948 Redwater discovery was still more significant. Others followed, including fields at Swan Hills and Big Valley. In 1953, Pembina became Canada's largest reserve, discovered by a geologist from Standard, Alberta. Although the Fort McMurray oil sands were known to fur traders, that development awaited the future.*

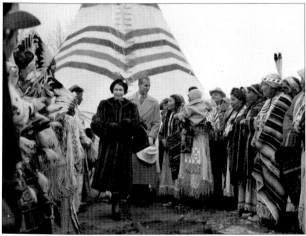

Bottom: *In October 1951, Princess Elizabeth attended gala events in Edmonton and square danced in Calgary.*

Six months later, she was Queen of Canada, Britain, and the Commonwealth. In 1939 her father, King George

Photo Credits

Alberta Sports Hall of Fame & Museum
89 top; 89 bottom

BARD University of Alberta Archives, Edmonton
58 (71-202)

City of Calgary Archives
110/111 (CR92-032, #218); (110 CR92-032, #274)

City of Edmonton Archives
5 (EA-160-30); 44 top (EB-13-27); 69 (EA-10-81); 73 (EA-25-41); 96 (EA-10-2023); 104 top (EA-122-25); 104 bottom (EA-160-446); 105 bottom (EA-160-1401)

City of Lethbridge Archives & Records Management (Galt Museum)
7 (P19891049061); 9 top (P19770245026); 9 bottom (P19731723022); 11 top (P19731723018); 36 top (P197660234135); 40 bottom (P19770261004); 41 top (P19770245030) 48 top (P19760216047); 48 bottom (P19760212045); 64 (P19738128000); 65 bottom (P19780260002); 68 bottom (P19760208042); 72 bottom (P19790275020); 75 bottom (P19740030033); 95 bottom (P19730036000); 102 top (P19730189000); 108/109 (P19760217078); 109 bottom (P19790284018)

Courtesy of the Fort Macleod Museum
13 bottom (FMP 18-131)

Field Museum of Natural History, Chicago
92 (45072)

Glenbow Archives, Calgary, Alberta
front cover (NA 2539-19); 2 (NA 4868-197); 8 top (NA 403-1); 8 bottom (NA 403-2); 11 bottom (NA 664-1); 12 left (NA 354-1); 12 right (NA 1237-1) 13 top (NA 550-18); 14 top (NA 659-26); 15 bottom (NA 40-1); 16 top (NA 1750-1); 16 bottom (NA 659-27); 17 (NA 3927-3); 18/19 (NA 1753-28); 21 top (NA 631-2); 21 bottom (NA 285-4); 22 top (NA 3697-1); 22 bottom (NA 2520-53); 24 (NA 550-4); 25 top (NA 1315-4); 26 top (NA 1323-10); 27 bottom (NA 424-2); 28 (NA 659-18); 29 bottom (NA 2769-1); 30 top (NA 1654-1) 30 bottom (NA 670-5); 31 top (NA 529-23); 31 bottom (NA 5234-2); 32 (NA 156-8); 33 top (NA 473-1); 33 bottom (NA 114-15); 34 top (NA 5366-2); 35 (NA 2864-13233); 37 (NA 2804-1); 38 top (NA 614-11); 38 bottom (NA 614-13); 39 top (NA 949-81); 39 bottom (NA 949-123); 41 bottom (NA 103-30); 42 top (NB 28-24); 42 bottom (NA 3583-5); 43 (NA 1655-1); 44 bottom (NA 140-1); 45 (NA 1075-12); 46 bottom (NA 915-13); 47 (NA 3551-58); 49 top

(NA 4140-7) ; 49 bottom (NA 659-100); 51 (NA 984-2); 52 (NA 3081-16); 53 bottom (NA 370-26); 54 top (NA 2650-1); 54 bottom (NA 2689-18); 56/57 (NA 748-41); 59 top (NA 474-4); 59 bottom (NA 3437-17); 60 top (NA 1604-2); 60 bottom (NA 5329-12); 62 top (PA 41-5); 63 (NA 463-32); 67 (ND 2-410); 68 top (NB 16-621); 70/71 (NB 32-12); 74 top (NA 2736-1); 75 top (NC 6-3695); 76 (NA 335-84); 77 top (NB (H) 16-260); 77 bottom (NA 628-4); 78 (NA 57-29); 79 top (NA 3250-10); 79 bottom (NA 2083-4); 81 (NA 1639-1); 82 (NB 16-90); 83 top (NC 6-3477); 83 bottom (NC 6-3238); 84 (NC 6-1747); 85 top (NC 6-3311); 86 bottom (NC 6-2396); 88 top (NA 463-44); 88 bottom (NB 16-504); 90 top (NA 3707-12); 91 top (ND 8-219); 91 bottom (ND 8-212); 93 top (ND 8-341); 94 top (NA 462-6); 94 bottom (NB(H) 16-409); 97 top (ND 3-5957); 97 bottom (NA 463-49); 99 bottom (NA 2377-1); 101 top (NC 6-12955(b)); 101 bottom (NA 2199-1); 102 bottom (NA 544-96); 103 top (NC 6-13068(b)); 103 bottom (NA 2389-9); 106/107 (NB 32-33); 106 bottom (NA 2748-1); 107 bottom (NB 32-16); 111 top right (NA 789-80); 111 bottom (NB 44-110(a)

Manitoba Archives
29 top (NA 1315-9)

Provincial Archives of Alberta
25 bottom (A5019); 27 top (B10102); 40 top (A2979); 53 top (A5024); 61 (B4152); 63 bottom (A2321); 65 top (A2922); 66 (A10762); 72 top (A2924); 74 bottom (A2910); 85 bottom (A7364); 86 top (A4837); 87 (A4814); 93 bottom (BA419); 95 top (A10177); 99 top (A10924); 100 (A2043); 105 (PA1579/2)

Red Deer & District Archives
55 (P234-68); 108 bottom (P348)

Eunice H. Hanna
108 left

Whyte Museum of the Canadian Rockies
back cover, 46 top (V653/NA 80-1130); 62 bottom (V484/NA29-18); 90 bottom (V683/N683/NA66-1658)

Faye Holt

Faye Reineberg Holt was born in Alberta and lives in Calgary. As well as having published articles, short fiction, and poetry, she has worked as a freelance editor on a variety of projects, including Altitude's *Calgary* and *Alberta: The Canadian West*. She also teaches writing workshops. At one time a high school English teacher and museum educator, she is an alumnus of the University of Alberta. This book is dedicated to the memory of her father, Carl Reineberg.